IMAGES
of America

FAIRFAX

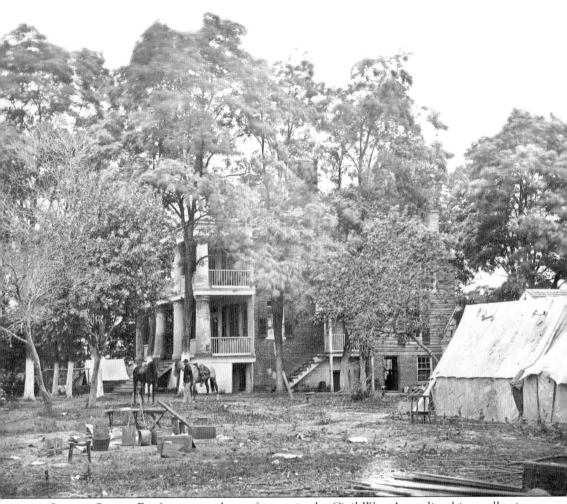

ON THE COVER: Fairfax saw its share of terror in the Civil War. According his recollections, which ran between 1866 and 1868 in *Harper's Monthly*, writer David Strother slept on a large box in the Fairfax County Courthouse. He was surprised to find a dead federal officer stowed within his makeshift bed. This 1862 photograph shows Dunleith near the Fairfax County Courthouse, which housed the headquarters of Union general George McClellan and Confederate general P.G.T. Beauregard at different times during the Civil War. (Courtesy of the Library of Congress.)

IMAGES
of America

FAIRFAX

Whitney Rhodes

ARCADIA
PUBLISHING

Published by Arcadia Publishing
Charleston, South Carolina

Printed in the United States of America

Library of Congress Control Number: 2013930702

For all general information, please contact Arcadia Publishing:
Telephone 843-853-2070
Fax 843-853-0044
E-mail sales@arcadiapublishing.com
For customer service and orders:
Toll-Free 1-888-313-2665

Visit us on the Internet at www.arcadiapublishing.com

*To Lee Hubbard, for his enthusiasm in
preserving and sharing Fairfax's past*

CONTENTS

FOREWORD

Nestled in the suburban expanse of the Washington, DC, metro region, the city of Fairfax, Virginia, with its hallmark landscaped and leafy street medians, is an oasis, unique and brimming with vitality that recently has been recognized by *Forbes* as one of the top three places to live in the nation. Our city is rich in history with unlimited possibilities for the future. The city has a reputation for achievement, as well as a place of enjoyment and fun for its residents.

Our residents aren't surprised with the city's many top rankings on "quality-of-life" lists. It simply comes with the territory for this small city of 24,000, known for its superior "small town" community feel situated in a world-class metropolitan region.

The city is widely known for outstanding historical and cultural amenities. We host annual Civil War reenactments every year and are home to some of the region's most historic properties, including the Fairfax County Courthouse, the Blenheim historical estate, the Ratcliffe-Allison House, and our very own Fairfax Museum and Visitor Center.

We also take pride in our world-class events, such as Fall for the Book, Spotlight on the Arts, and a fun two-day Chocolate Lovers Festival. This is in addition to our three annual flagship events, the daylong Independence Day festival, long recognized as having the best parade and most colorful fireworks in the area; our brilliant October Fall Festival, where our closed-off downtown streets are clogged with hundreds of renown craft merchants and thousands of visitors, and our Holiday Craft Show, which fills our high school with amazing handcrafted wares that bring shoppers from surrounding states.

Acclaimed George Mason University sits on the city's southern border and, through a cooperative town-gown relationship, provides world-class thinkers, musical and cultural events, and nationally recognized sports teams with Olympic-caliber athletes.

The city of Fairfax has a sense of place, a sense of history, and a sense of belonging. Come visit us.

—Mayor Scott Silverthorne

ACKNOWLEDGMENTS

The author would like to thank the Virginia Room staff at the City of Fairfax Regional Library for their hours spent searching through boxes of photograph archives and retrieving materials over the months-long creation of this book. Special thanks goes to Page Johnson and Lee Hubbard for walking me through the more complicated historic stories and helping me identify landmarks and people in some of the older photographs. This book would still be just an idea without the guidance and support of Susan Gray, curator for the Fairfax Museum and Visitor Center. Thanks go to my editor and the staff at Arcadia Publishing for correcting my mistakes and making this project possible.

INTRODUCTION

The city of Fairfax's humble beginnings started with the relocation of the Fairfax County Courthouse from Alexandria to farmland and wilderness in the center of Fairfax County in 1800. Populated by courthouse employees, the small town was eventually named the town of Providence, though most called it Fairfax Court House after its central landmark.

Located southwest of Washington, DC, Fairfax proved to be a hotly contested area during the Civil War. The town changed hands between Union and Confederate troops a number of times, leaving much of the courthouse and surrounding businesses and farms in ruins at the end of the war. Residents picked up the remnants of their once-quiet lives and rebuilt their homes. Historians are still uncovering stories and artifacts from that time.

Fairfax gradually grew out of its farming focus. The area around the Fairfax County Courthouse became a bustling downtown. Its population increased dramatically in the 20th century. Tourist camps like those at Kamp Washington and Fairfax Circle attracted travelers. Trade saw a boost from the Washington, Arlington & Falls Church Railway as well as newly paved roads and highways.

The city of Fairfax split from Fairfax County in 1961. Residents built a new city hall, started their own fire and police departments, and elected a school board. Tourist camps were replaced by car dealerships and strip malls. Downtown Fairfax expanded to include more mom-and-pop shops. Fairfax County Courthouse moved a few blocks down Chain Bridge Road, leaving the old courthouse as a historical landmark. George Mason College, now a university, opened on the border of the thriving city.

These chapters illustrate a glimpse of Fairfax during these points in time. Information comes from microfilm-preserved newspaper articles and accounts from local historians. Hundreds of historical photographs were left out due to space limits. This author strongly suggests spending a few afternoons browsing the Virginia Room at the City of Fairfax Regional Library or stopping by the Fairfax Museum and Visitor Center for a more in-depth look at some of the stories the city of Fairfax begs to offer. Hopefully this book encourages readers to start a historical investigation of their own.

One

CIVIL WAR

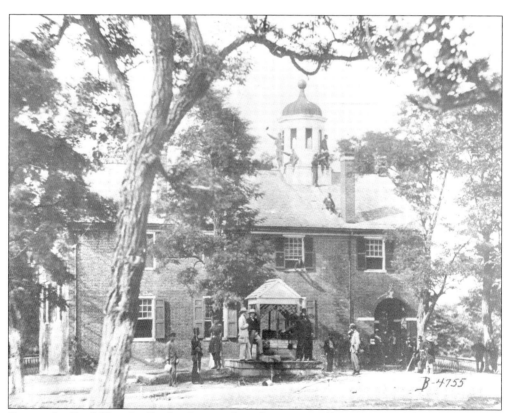

During the Civil War, the Fairfax County Courthouse passed between Confederate and Union troops numerous times, eventually falling to Union possession in the spring of 1862. The war took a heavy toll on the courthouse. Pieces of the property were burned and trashed, and records within the government building went missing or were destroyed. This photograph shows the courthouse in 1863. (Courtesy of the Virginia Room, Fairfax County Public Library.)

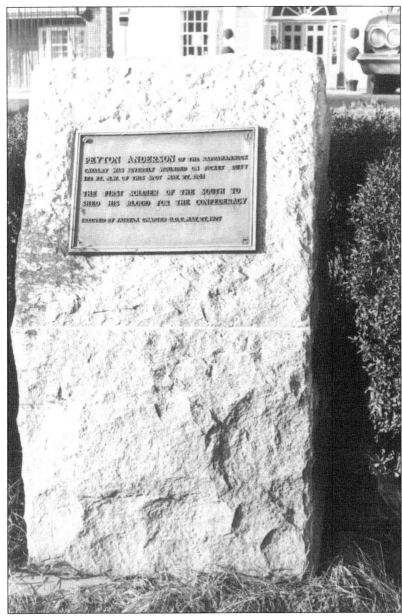

Pvt. Peyton L. Anderson Jr., 23, of Rappahannock County was the first Confederate soldier to shed blood in the Civil War. Anderson and his peer, William Lillard, were on picket duty for Company B, 6th Virginia Cavalry, when they encountered a squad of Union horsemen on May 27, 1861. Lillard was taken to Washington, the first Confederate prisoner of war. Anderson was shot and left to die. He eventually made his way to Fairfax Court House, where he was treated and discharged a few weeks later. Anderson reenlisted with Col. John S. Mosby's Partisan Rangers. He died on January 12, 1914. This marker, shown in 1972 and located east of Fairfax County Courthouse, where Anderson was shot, honors his sacrifice. The Fairfax Chapter of the United Daughters of the Confederacy erected the monument near the present-day corner of Lee Highway and Blake Lane in May 1927. It was later moved to Fairfax Boulevard near the former White House Motel, now the Rodeway Inn. (Courtesy of the Virginia Room, Fairfax County Public Library.)

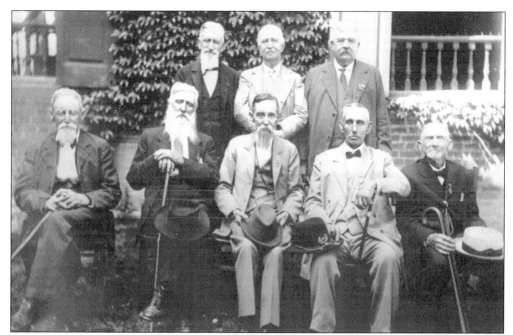

The last reunion of the Confederate Veterans of Marr Camp gathered for this photograph in the late 1920s. Shown from left to right are (first row) James H. Wiley, Charles E. Davis, Capt. Robert Wiley, J. Nelson Follin, and John P. Chinn; (second row) Thomas H. Lee, Dr. Charles F. Russell, and George K. Pickett. (Courtesy of Lee Hubbard.)

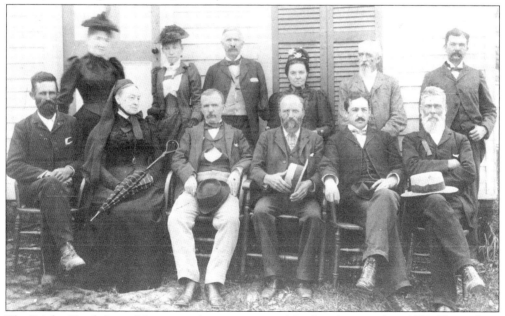

The Fairfax Confederate Monument Association posed for this photograph in 1890. Shown from left to right are (first row) George Harrison, Mrs. Thomas Moore, F.W. Richardson, Mr. Sager, R. Walton Moore, and George Gordon; (second row) Rose Thomas, Lizzie Burke, Judge James Love, Mrs. Gurley, Mr. Gurley, and George Pickett. (Courtesy of the Virginia Room, Fairfax County Public Library.)

11

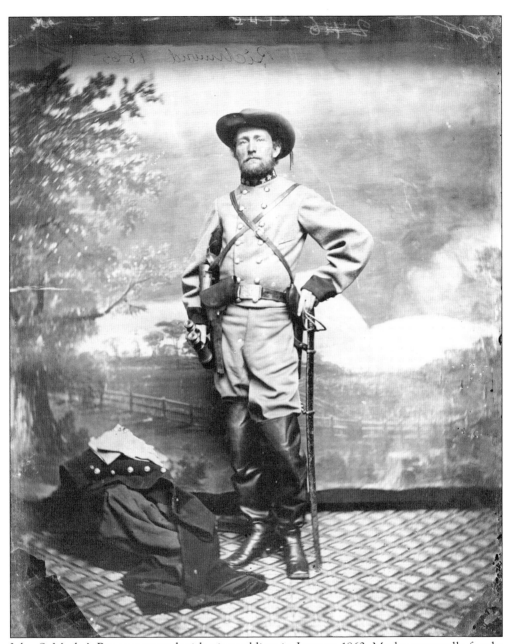

John S. Mosby's Rangers started with nine soldiers in January 1863. Mosby eventually fought alongside over 1,900 men during his time leading surprise attacks and raids throughout the Civil War. His unit became official as the 43rd Battalion of Virginia Cavalry in June 1863. He coordinated attacks with other Confederate plans and focused on demoralizing the Union army. Throughout his career for the Confederacy, Mosby reached the ranks of captain, major, lieutenant colonel, and colonel. He suffered a major wound in his thigh and side on August 23, 1863, in Annandale. Mosby would later endure a serious of other injuries during his time fighting Union soldiers, though none was as severe as when he was shot in the abdomen near Rector's Crossroads in Virginia in 1864. Though left for dead, Mosby survived and continued to fight until he disbanded his Rangers in 1865. (Courtesy of the Library of Congress.)

John Singleton Mosby led his men to capture Brig. Gen. Edwin H. Stoughton, Lieutenant Prentiss, 2 captains, 30 other prisoners, and 58 horses at the William Gunnell House in March 1863. The incident caught the Union troops by surprise, many of whom were bewildered in their nightclothes by the Mosby Raiders. This photograph shows the Gunnell House in November 1967. (Courtesy of the Virginia Room, Fairfax County Public Library.)

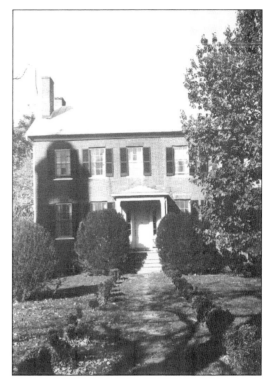

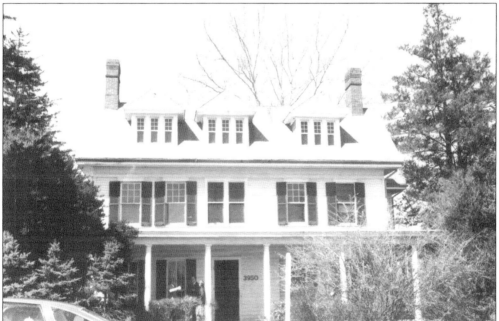

John S. Mosby also searched the Moore House for Union colonel Percy Wyndham. Spurred on by an insult (Wyndham called Mosby a horse thief), Mosby and his Rangers stopped by the Moore House on the same night as his Gunnell House raid; he did not find Wyndham. This photograph shows the Moore House in 1982. (Courtesy of the Virginia Room, Fairfax County Public Library.)

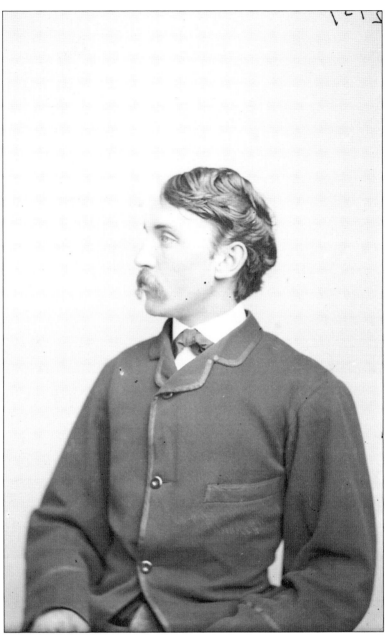

Edwin Henry Stoughton served as brigadier general of volunteers and was assigned the lead of the 2nd Vermont Brigade in 1862. A few months later, Mosby captured Stoughton sleeping in a bed at the William Gunnell House near the Fairfax County Courthouse. Several historians claim that Mosby woke Stoughton with a slap on the rump. The brigadier general supposedly woke and shouted, "Do you know who I am?" to which Mosby asked, "Do you know Mosby, general?" Stoughton said, "Yes! Have you got the rascal?" Mosby retorted, "No, but he's got you!" Stoughton was later exchanged back to Union forces but did not fight again. Pres. Abraham Lincoln allegedly thought more of the horses stolen that night than the brigadier general. Stoughton became a lawyer after the war. He died in 1868, when he was only 30 years old, in New York City. (Courtesy of the Library of Congress.)

Coombe Cottage served as a boarding school for young women from 1844 to 1863. The school was located on Little River Turnpike, now known as Main Street, next to Truro Church. Owners Hannah Maria Baker and Dr. Frederick Baker charged $125 per year for room and board. This photograph shows the last remaining building in the school complex before its demolition in 1955. (Courtesy of the Virginia Room, Fairfax County Public Library.)

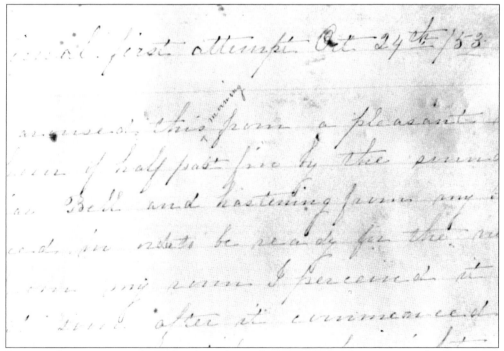

Frances Ellen Carper, 15, kept this diary during her stay at Coombe Cottage. The diary starts on October 24, 1853. She was one of about 17 girls studying at the school at the time. Carper was from Dranesville, though some of her peers hailed from as far away as Indiana. She studied with Antonia Ford, Laura Ratcliffe, and Susanna Steel. (Courtesy of the Virginia Room, Fairfax County Public Library.)

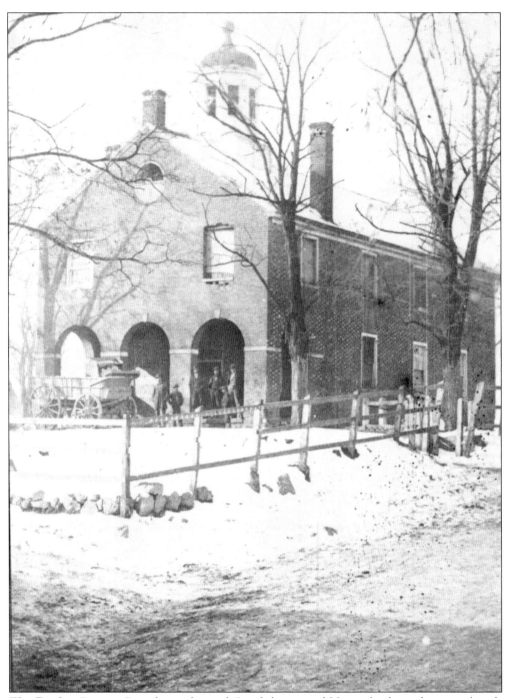

The Fairfax County Courthouse housed Confederate and Union leaders, changing hands several times in the first year of the Civil War. Confederate president Jefferson Davis visited the courthouse, and Union general George McClellan and some of his Army of the Potomac camped there with 36,000 soldiers from eight different states. This photograph shows the Fairfax County Courthouse from the northeast with Civil War soldiers and a wagon parked in the front in 1862. (Courtesy of the Virginia Room, Fairfax County Public Library.)

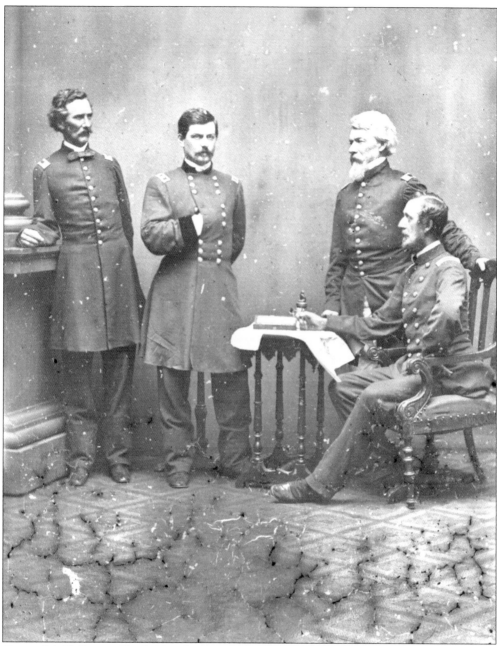

George McClellan, or "Little Napoleon," was the commander of the Army of the Potomac and eventual general-in-chief of all Union armies. McClellan harbored fears that his men were up against a much larger Confederate force. His cautious battle style put him at odds with Pres. Abraham Lincoln. This photograph shows McClellan and his staff. Shown from left to right are Captain Clark, General McClellan, Captain Van Vliet, and Major Barry. Civil War life was difficult for its soldiers. One patriotic drawing at Blenheim depicts a soldier poised behind a cannon, cannonballs at the ready at its side. Close to the cannon doodle is another drawing showing a bedraggled soldier with the following text: "4th month / No money / No whiskey / No friends / No rations / No peas / No beans / No pants / No Patriotism." (Courtesy of the Library of Congress.)

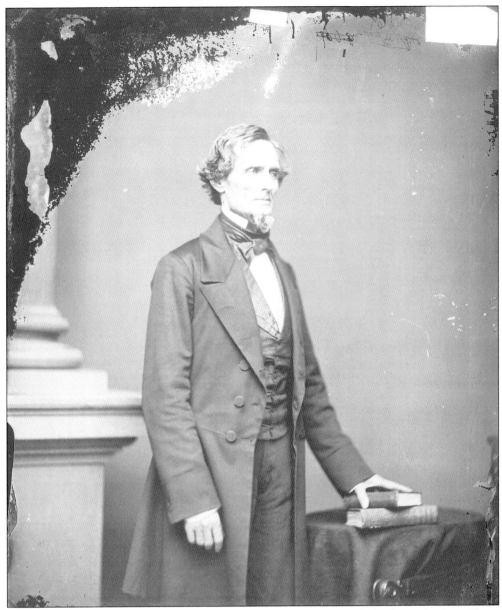

Locals turned out to watch Confederate president Jefferson Davis march the four miles from Chain Bridge Road to the Fairfax County Courthouse on September 30, 1861. They cheered his arrival on a white horse, riding just in front of those escorting him, according to one reporter. Davis chatted away with General Beauregard and took a few turns acknowledging his onlookers. Davis made a short speech to the troops gathered at Dunleith. It is transcribed here in full, courtesy of the *Charleston Courier*: "Soldiers: Generals Beauregard and Johnston are here, the orators of the day. They speak from the mouths of cannon, of muskets and rifles; and when they speak, the country listens. I will keep silent." The following day, Davis rode around the encampment, inspecting the troops. That night, he ate with Gen. Joseph Johnston at Coombe Cottage. (Courtesy of the National Archives.)

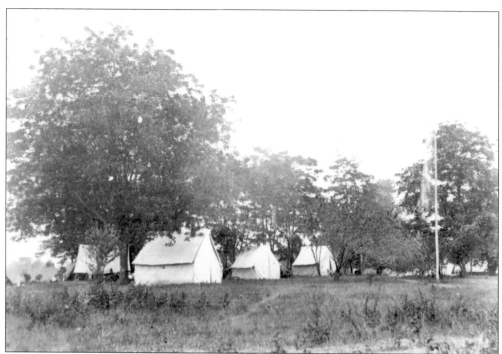

General Beauregard camped his Confederate Army of the Potomac near the Fairfax County Courthouse. The *Charleston Courier* described it as follows: "Every house is a boarding house and all are filled. Those who can get a comfortable bed on the floor are fortunate. . . . This is a large city now in all but houses. People live out of doors and glad of the shelter of a tent." This photograph shows the headquarters of the Army of the Potomac in June 1863. (Courtesy of the Library of Congress.)

Gen. Pierre Gustave Toutant Beauregard led his troops to victory in the First Battle of Bull Run and fought in a number of other major struggles, including the Battle of Shiloh and Siege of Corinth. He deterred Union forces from the Confederate capital, Richmond, by saving Petersburg, Virginia, in June 1864. Beauregard lived a wealthy life after the Civil War. He died in Louisiana in 1893. (Courtesy of the Library of Congress.)

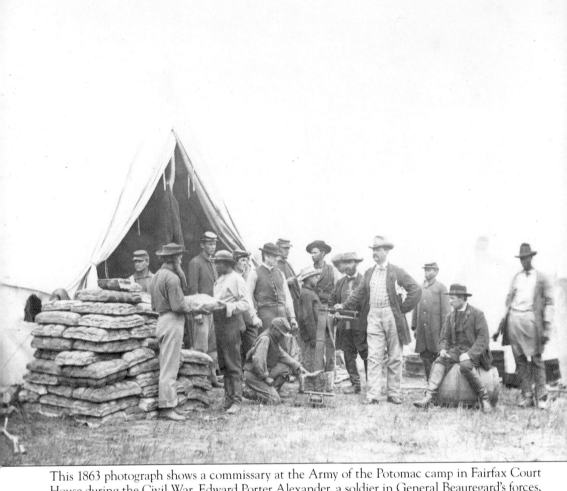

This 1863 photograph shows a commissary at the Army of the Potomac camp in Fairfax Court House during the Civil War. Edward Porter Alexander, a soldier in General Beauregard's forces, wrote his wife, Bettie, in August 1861, after the First Battle of Bull Run. In the letter, he bemoaned the lack of supplies from the army's commissary general. The commissary, like in the Army of the Potomac shown above at Fairfax Court House, provided provisions for Confederate forces on the move. He wrote to his wife: "We can do nothing now for want of provisions, for our army is actually almost starving. They appointed . . . a man who in the old Army had not seen his company or done a minute's work for seventeen years, and this is the result of it. . . . Oh, Pidge, I do want to see you awfully, but won't we be happy when Old Lincoln dies and the war is over. Just think of it!!!!!!" (Courtesy of the Library of Congress.)

Constructed in 1859, Blenheim holds more than 100 signatures, drawings, and poetry from Union soldiers during their stay at the Fairfax Court House area in the Civil War. Blenheim was owned by the Willcoxon family at the time. The Union soldiers occupied the farmhouse at intervals from 1862 to 1863. This photograph shows Blenheim in 1937. Historians and conservation technicians stripped the Blenheim walls of wallpaper, removed door moldings and fireplace mantels, and went to work hunting for more signatures and drawings. Kirsten Travers removed parts of paint with a chemical stripper, a cotton swab, and water. Page Johnson, historian and commissioner of revenue for the City of Fairfax, believes the Willcoxon family painted the walls of their home once they returned after the Civil War. Visitors can see the signatures on a full-size replica in the Blenheim Interpretive Center. (Courtesy of the Virginia Room, Fairfax County Public Library.)

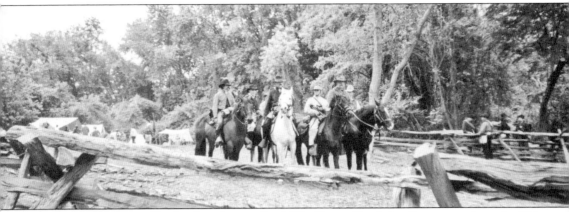

Every year, Historic Fairfax, Inc., hosts a Civil War Day at Blenheim. Reenactors from the 17th Virginia Infantry Company and Fairfax Rifles file about the property and portray fake skirmishes to help visitors relive the Civil War experience near the Fairfax County Courthouse. This photograph shows a group of reenactors at Civil War Day in 2002. Blenheim was built around 1859 and owned by Rezin Willcoxon. It was occupied by Union soldiers from 1862 to 1863. The historic Blenheim property now houses the Civil War Interpretive Center at Historic Blenheim and Grandma's Cottage. The cottage was built around 1840. Margaret Conn Willcoxon Farr, daughter of Rezin Willcoxon, lived in the cottage until she died and was buried in the Blenheim cemetery. Grandma's Cottage was located at the intersection of Old Lee Highway and Main Street, then Old Lee Highway, near Layton Hall Drive before reaching Blenheim. (Courtesy of the Virginia Room, Fairfax County Public Library.)

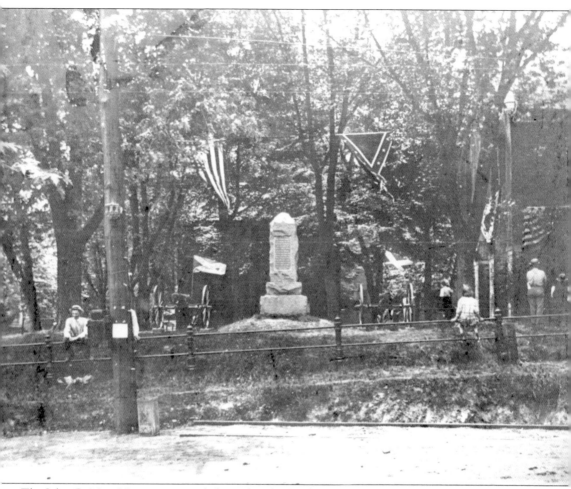

The John Q. Marr Monument was dedicated at the Fairfax County Courthouse on June 1, 1904. This photograph shows the monument during an annual celebration in 1905. The Washington, Arlington, & Falls Church Railway tracks, which extended to Fairfax in 1904, are shown in the foreground. Marr was born in Warrenton in Fauquier County. The captain of the Warrenton Rifles, Marr was appointed lieutenant colonel of Virginia Volunteers in 1961. He was killed a month later at the age of 36. The Marr Monument stands next to two Confederate Navy cannons. Both cannons are pointed north. A pile of cannonballs used to sit between the cannons near the Marr Monument. Local kids were known to send them rolling down Main Street at night, even after the cannonballs were welded together. The nuisance was enough to get the cannonballs removed from the courthouse property. (Courtesy of Lee Hubbard.)

John Quincy Marr was the first Confederate officer killed in the Civil War on June 1, 1861. Union troops caught the Confederates by surprise. Virginia governor William "Extra Billy" Smith took command of the confused troops. Marr's body was located the next morning in a clover field by "Uncle" Jack Rowe. Marr was buried in Warrenton Cemetery. This photograph shows the dedication of the Marr Monument in 1904. Historians are not sure who fired the shot that killed Marr. They believe he stumbled across the Union's 2nd US Cavalry Regiment as it rode through Fairfax. The gunshot could have come from one of the Union men or another startled Confederate soldier. Lt. Charles Tompkins, the man leading the 2nd Cavalry at the time, received a Congressional Medal of Honor that suggests he shot Marr, though it seems to be the only documentation to name a shooter. (Courtesy of Lee Hubbard.)

William "Extra Billy" Smith was elected to the Virginia Senate in 1836. He was reelected in 1840, though he resigned in 1841 to run for the US House of Representatives. Smith won that election but lost the next. In 1846, Smith was inaugurated as governor of Virginia for a three-year term. (Courtesy of the Library of Congress.)

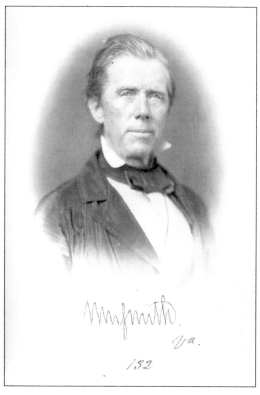

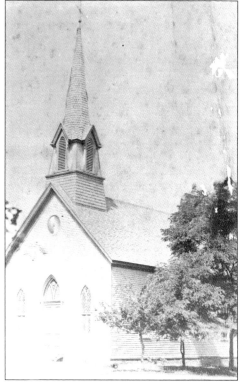

John Quincy Marr's Warrenton Rifles stayed at Duncan's Chapel in May 1861. Known then as a Methodist church, the chapel later served as a stable for Union horses and was left in a sorry state, burned, and destroyed at the end of the Civil War. Church members rebuilt the chapel, adding a nine-room parsonage in 1882. This photograph shows the chapel in 1915. (Courtesy of the Virginia Room, Fairfax County Public Library.)

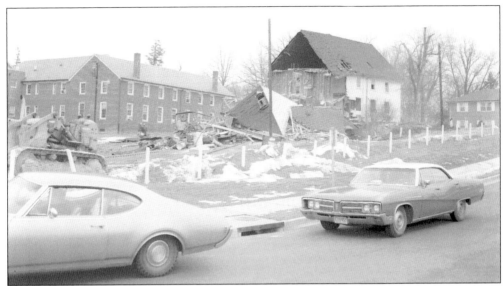

This photograph shows the demolition of the old Methodist church (Duncan's Chapel) on Chain Bridge Road on January 19, 1970. The parking lot facing Chain Bridge Road just north of the entrance to the Massey Building used to be part of the church property. (Courtesy of Lee Hubbard.)

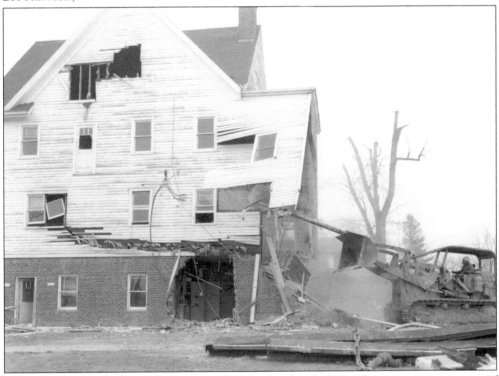

Duncan's Chapel was demolished between late 1969 and early 1970. The property is now part of a parking lot south of the Fairfax County Judicial Center. The street that used to separate the Fairfax County Courthouse from Duncan's Chapel is now part of judicial center open space. (Courtesy of the Virginia Room, Fairfax County Public Library.)

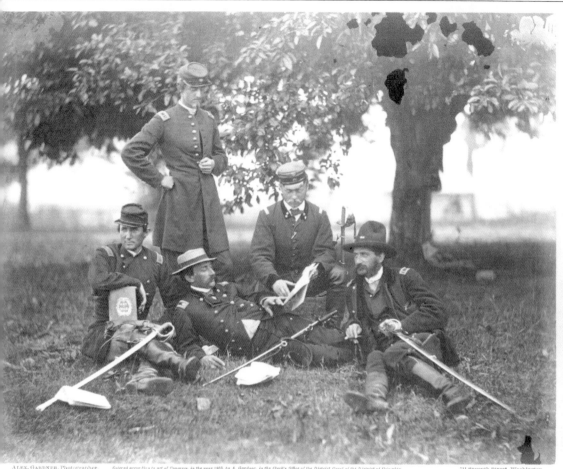

STUDYING THE ART OF WAR.

This photograph, taken in June 1863, shows Col. Ulric Dahlgren, Lieutenant Colonel Dickinson, Count Zeppalin, Major Ludlow, and Lieutenant Rosencranz. One of the soldiers holds a book titled *The Art of War*. They sit near the Fairfax County Courthouse at the headquarters of the Army of the Potomac. The photographer, Alexander Gardner, captured this image. It and other scenes from the Civil War were found in his 1866 book *Gardner's Photographic Sketch Book of the War*. Gardner's sketch book also depicts a group of Confederate prisoners dressed in civilian trousers and hats near the Fairfax County Courthouse, a gathering of scouts and guides to the Army of the Potomac in Maryland, and the general post office of the Army of the Potomac in Culpeper, Virginia. The book is now digitized on the Cornell University Library website and housed in the school's Division of Rare and Manuscript Collections. (Courtesy of the Library of Congress.)

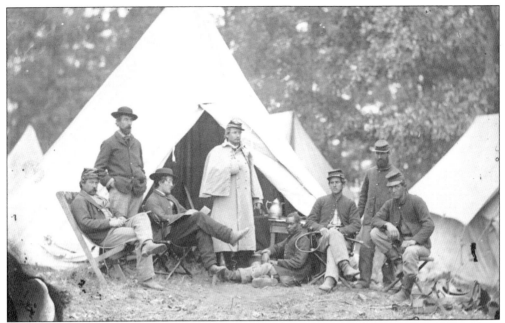

These photographs were taken near Fairfax Court House in 1863. Both photographs show Capt. J.B. Howard with a group of soldiers at the Army of the Potomac's office of the assistant quartermaster. A *New York Times* article dated April 10, 1864, gives Howard the title of "Lieutenant Colonel of the Cavalry Corps." The article goes on to list the names and titles of numerous other quartermasters of the Army of the Potomac during the Civil War. Created in 1861, the Army of the Potomac grew to a massive army that eventually split into different corps. Maj. Gen. George B. McClellan formed the Army of the Potomac by merging military departments. It fought in many of the major battles in Virginia, Maryland, and Pennsylvania. The army consisted of several prominent units, including the Irish, Philadelphia, 1st New Jersey, and Iron Brigades. (Both, courtesy of the Library of Congress.)

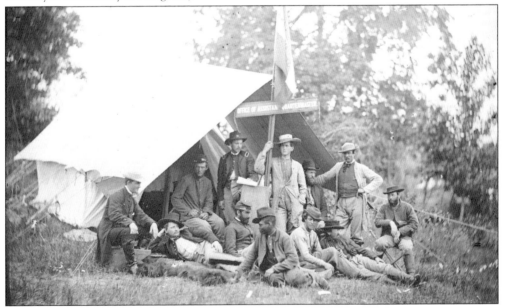

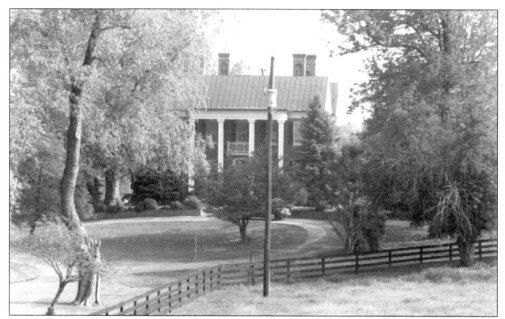

Samuel Farr received this Main Street property in 1797 for his work with the Continental Army. Five Chimneys, the Farr family home located at Route 123 and Braddock Road, burned at the start of the Civil War after Richard Ratcliffe Farr, 14 at the time, engaged and chased off Union troops. The home pictured was built in 1880. It is currently a private residence at the end of a long drive near downtown Fairfax. This photograph was taken in 1988. (Courtesy of the Virginia Room, Fairfax County Public Library.)

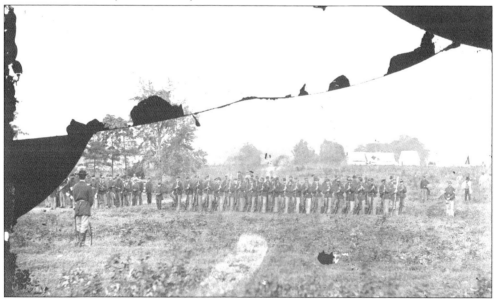

This photograph shows the 8th US Infantry Provost Guard at the headquarters of the Army of the Potomac near the Fairfax County Courthouse in 1863. The *Charleston Courier* described the scene as such: "All hearts are buoyant and happy today. Men look upon the presence of our honored Chief Magistrate among us as a guarantee that the hour is close at hand when they will be permitted to strike a blow for . . . the land they love." (Courtesy of the Library of Congress.)

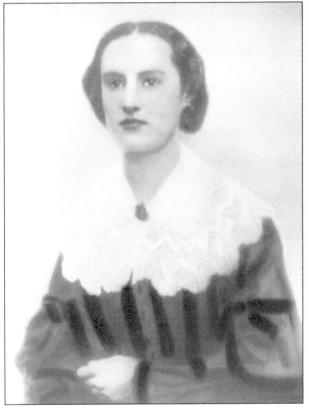

The home of the Ford family and Antonia Jane Ford stands on Chain Bridge Road in this 1978 photograph. Inside this house, investigators found an honorary aide-de-camp commission from Gen. J.E.B. Stuart to Antonia Ford. She was accused of helping the Confederates after Mosby's Raid and imprisoned for being a spy in 1863. (Courtesy of the Virginia Room, Fairfax County Public Library.)

Antonia Jane Ford was born on July 23, 1838, and died on February 14, 1871. After she was imprisoned for allegedly spying for Confederate general J.E.B. Stuart, Ford fell in love with and married jailer Maj. Joseph Clapp Willard. She spent only seven months in jail. Their son, Joseph Willard, built Old Town Hall. This scan of a photonegative shows a portrait-type photograph of Antonia. (Courtesy of Lee Hubbard.)

Two

FARMS TO FOUNDING

Fairfax Hay and Grain first operated as Alexandria Hay and Grain with a store of the same name based in Alexandria. Mary Cullen, later Haight, worked as manager. Herman Franklin later took over the business and changed the name to Fairfax Hay and Grain. Lynn Bryce and Ted McKay operated the business after Franklin. The building now houses the Executive Press shop. (Courtesy of the Virginia Room, Fairfax County Public Library.)

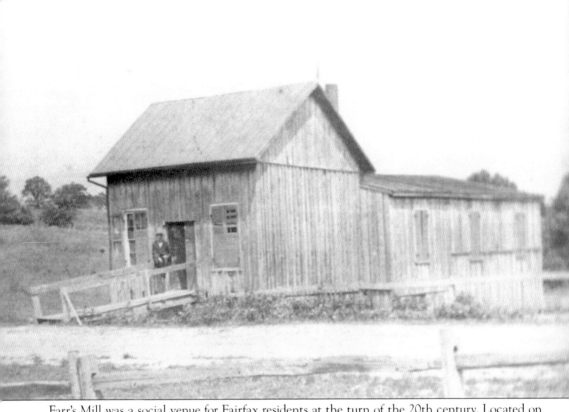

Farr's Mill was a social venue for Fairfax residents at the turn of the 20th century. Located on the north side of Main Street near the Farr home, the steam-powered mill hosted countless balls and "Germans," or social gatherings and dances. These Germans were popular in the later 19th century. Also called "cotillion" or "German cotillion," the dances were led by a conductor to waltz music. Dancers played games as directed by the conductor during these dances. At times dancers would win or lose the games, for which there were prizes and props. The dance games could be simple, derived from dances many in the social scene had already mastered, or complicated. Germans were popular social dances of the time along with the quadrille, waltz, and the two-step. This photograph was taken in the early 1900s. (Courtesy of the Virginia Room, Fairfax County Public Library.)

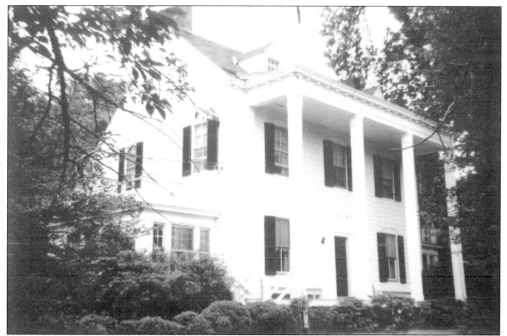

The Schuerman House stood on a road of the same name until Charles Pickett, a local lawyer, purchased the land and the road's name was changed in his honor. Another older Schuerman house, known by some as the Krasnow House, was located south of the Schuerman House bought by Pickett. It was later demolished. Mattie Schuerman married Charles Baughman, who worked at the Swayze Farm only a short ways down the street. (Courtesy of the Virginia Room, Fairfax County Public Library.)

This undated photograph shows the Schuerman barn. The intersection of Schuerman/Pickett Road and Main Street was moved east by about 100 yards to make way for the construction of the Pickett Road Shopping Center. (Courtesy of the Virginia Room, Fairfax County Public Library.)

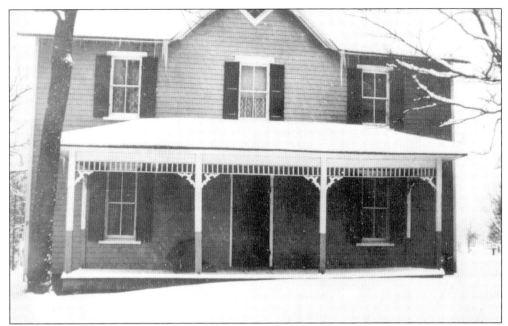

This is the home of the Swayze family. E.E. Swayze and his wife, Jennie Reid Swayze, lived here. Marie Moore Swayze was born here in 1900. She married Jerome Marks Gibson in 1927. E.E. Swayze and his wife died only about three days apart and were buried in the Fairfax Cemetery. Marie and her brother, Everett, sold the Swayze property to John Connelly 1939 to settle their father's estate. (Courtesy of Lee Hubbard.)

The Swayze Farm was located where the Army Navy Country Club currently stands. The Swayze family lived here, excluding E.E. Swayze's sisters, Ora, Minne, and Maggie, who lived next to the Methodist parsonage. Maggie Swayze was the first telephone operator in Fairfax. (Courtesy of Lee Hubbard.)

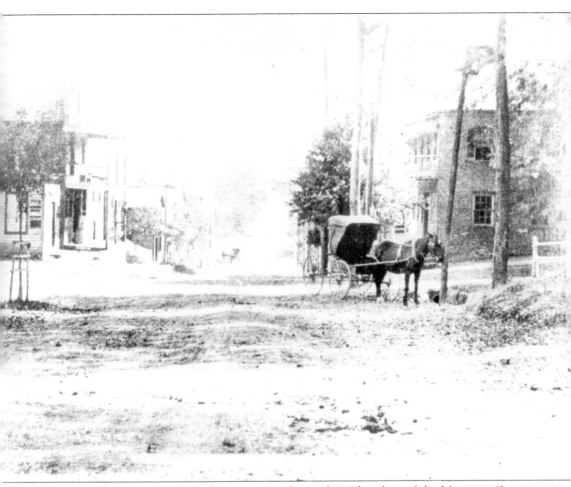

Fairfax Court House came close to housing part of an independent line of the Manassas Gap Railroad in the late 19th century. All area residents and businessmen had to do was raise $30,000 for the 35-mile line to run from Alexandria to Gainesville. It would run parallel to Little River Turnpike, passing south of the current Pickett Road Tank Farm and through Little River Hills, Fairview, and Farrcroft. The money was raised and construction started in 1854, but the line saw numerous setbacks. Workers struggled to level the ground where the track was supposed to run, and labor setbacks and increasing expenses made construction a slow, painful process. Then the Civil War destroyed much of the work that had been accomplished. The line was never finished. Remnants of it can still be found in the Westmore neighborhood and behind the Fairfax Presbyterian Church. (Courtesy of the Fairfax Museum and Visitor Center.)

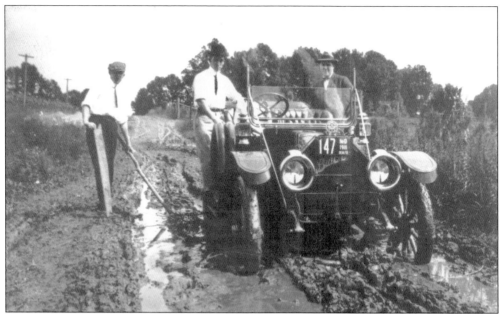

Before the start of the Washington, Arlington & Falls Church Railway, Fairfax commuters had to rely on their own two feet, horseback, and horse-drawn carriage to travel the area's muddy, sometimes impassable dirt roads. Fairfax did not get its first paved roads until 1920. Back then, the dirt roads were maintained by local property owners, who often took to making the roads passable by pick, shovel, and horse-drawn drag. (Courtesy of the Virginia Room, Fairfax County Public Library.)

Virginia used chain gangs to help maintain its roadways. This photograph shows such a gang working along Lee Highway in 1924. Convicts were not allowed to work on the roads until 1906, when the Virginia General Assembly adopted the Convict Road Force Act. Under the law, anyone convicted of a felony and serving at least two years in jail was fair game for chain gang labor. (Courtesy of Lee Hubbard.)

Lee Highway, constructed in honor of Confederate general Robert E. Lee, made its debut as the second paved road in Fairfax County in the 1920s. Locals Charles Kaiser, Lee Makel, Fairfax S. McCandlish, Robert J. Miller, James W. Pobst, John W. Rust, Col. Consuelo A. Seoane, and Lehman H. Young formed the Lee Highway Committee, a group instrumental in completing the paved road. This photograph shows paving on Lee Highway east of Blake Lane in 1924. (Courtesy of Lee Hubbard.)

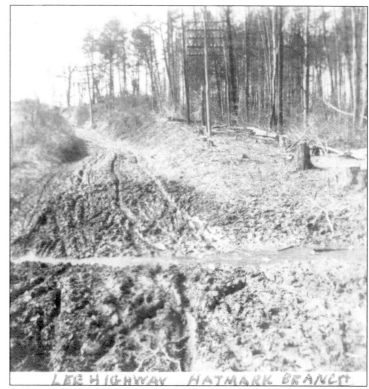

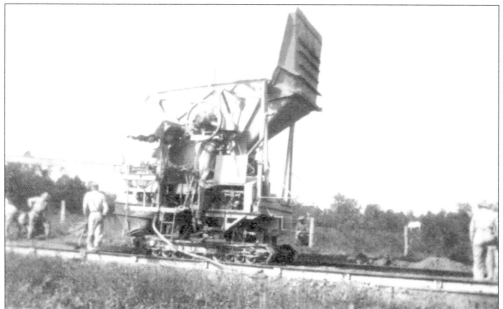

Lee Highway was widened to 27 feet in the late 1920s, not long after its completion. Today, the road runs 412 miles long in Virginia from Memorial Bridge in Arlington to State Street in Bristol. Lee Highway is 3,700 miles in its entirety, running from Washington, DC, to San Diego, California, as part of the Lee Highway National Auto Trail. This photograph shows paving on Lee Highway east of Blake Lane in 1924. (Courtesy of Lee Hubbard.)

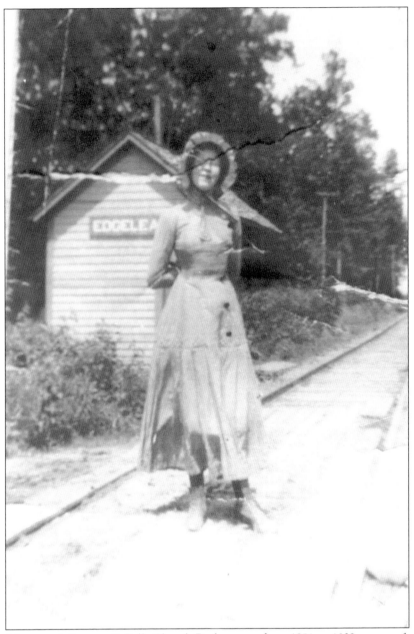

The Washington, Arlington & Falls Church Railway ran from 1891 to 1932 as one of only two electric lines in Northern Virginia. It traveled from Washington, DC, to Fairfax Court House. The railway first opened in 1892, when it completed its first terminal in Washington, DC, at Twelfth Avenue and Pennsylvania Avenue, NW. It took 12 years for the line to reach as far west as Fairfax Court House. The railway reached Fairfax in December 1904. It passed west through Clarendon, Rosslyn, Ballston, Falls Church, Dunn Loring, Vienna, and Oakton. Remnants of the line still exist on Railroad Avenue, including parts of a demolished railroad bridge between Fairfax Village Drive and Ranger Road. This photograph shows an unidentified woman standing at Edgelea Station near Blake Lane in 1918. (Courtesy of the Virginia Room, Fairfax County Public Library.)

Electric Depot stood along Main Street west of the Fairfax County Courthouse at Railroad Avenue. William Rumsey owned a large estate west of the depot. Rev. Richard Brown kept a Truro Church rectory at Fairfax Cemetery to the east until he sold it to the Fairfax Ladies Memorial Association in 1866. That land was used as a burial site for Fairfax Confederate soldiers. (Courtesy of the Fairfax Museum and Visitor Center.)

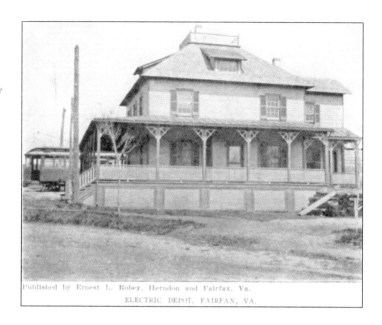

Published by Ernest L. Robey, Herndon and Fairfax, Va.
ELECTRIC DEPOT, FAIRFAX, VA.

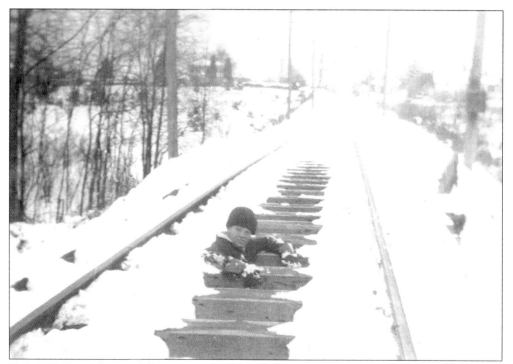

Today's Railroad Avenue follows the path of the Washington, Arlington & Falls Church Railway. The Fairfax Depot on Main Street held the Electric Depot and electric railway station, a feed and livery station, the Fairfax Cemetery, and Gaines Blacksmith Shop, as well as a black school and black Methodist church. This photograph shows a child playing near the electric railway tracks in the 1920s. (Courtesy of the Virginia Room, Fairfax County Public Library.)

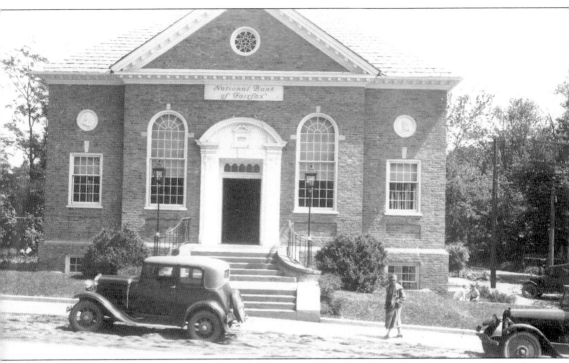

The National Bank of Fairfax, a first in the town of Fairfax, allowed residents to conduct their financial needs without having to travel to Alexandria or Washington. Fairfax historians point to Robert Walton Moore, the man who brought electric train service to Fairfax, as the start of the bank's board of directors. The bank originally leased space in the old Fairfax County Clerk's Office until a new home was constructed at 4029 Chain Bridge Road. There, the bank got its start from 1905 to 1931. This photograph of the National Bank of Fairfax shows the bank's second constructed home in 1931. Albert Reuben Sherwood was hired to do the honors. The bank took over the property formerly occupied by the Willcoxon Tavern. It merged with First & Merchants Bank in 1981. It is now the site of Bank of America. (Courtesy of the Virginia Room, Fairfax County Public Library.)

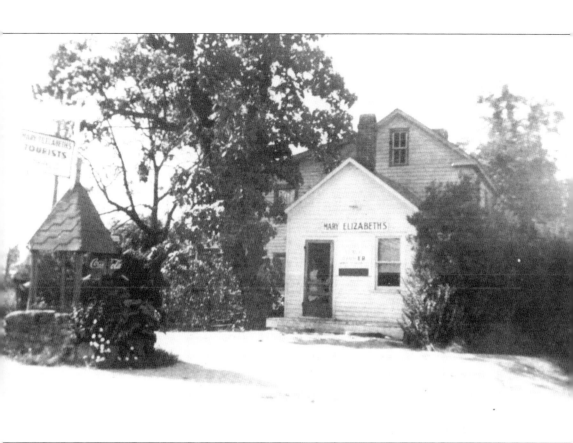

This photograph shows Mary Elizabeth's Tourist Home in Fairfax in the 1930s. It was one of several tourist highlights, including tourist cabins on Lee Highway, later operated as Ade's Camp Comfort; Kamp Washington at Little River Turnpike and Lee Highway; and the Sherwood House, which welcomed tourists in the early 20th century. (Courtesy of the Virginia Room, Fairfax County Public Library.)

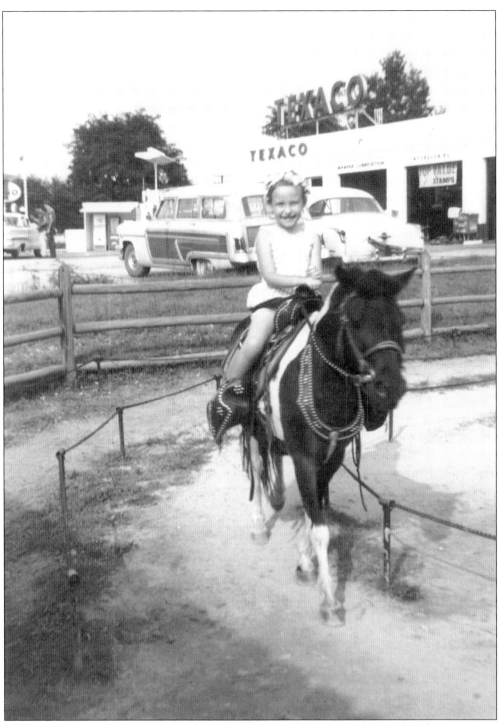

Karen Ann Moore, seven, spent the day at Bernie's Pony Ring in Fairfax Circle. The attraction, located south of McDonald's at Fairfax Circle, offered pony rides and drew families from all over Northern Virginia. This photograph was taken in 1960 by Glenn Moore. (Courtesy of the Virginia Room, Fairfax County Public Library.)

Frank C. Gibson built a store and tourist cabins after Lee Highway was paved in 1924. It was later purchased by a new owner and operated as Ade's Camp Comfort. The cabins were advertised as modern cottages with access to a lunch room and service station. This photograph was taken in the late 1920s. (Courtesy of Lee Hubbard.)

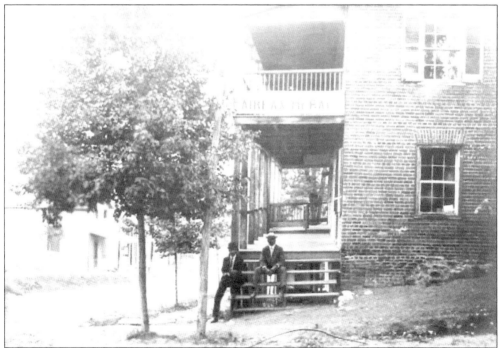

Fairfax Herald operated from 1882 to 1966. This photograph shows the location of the newspaper around 1882 at the corner of Main Street and Chain Bridge Road. The local newspaper was started by Capt. S.R. Donohoe. Roszel Donohoe worked as the editor for a time. He also served as the state senator for Fairfax County from 1898 to 1900. That seat is now held by John Chapman "Chap" Petersen, his great-great-grandson. (Courtesy of Lee Hubbard.)

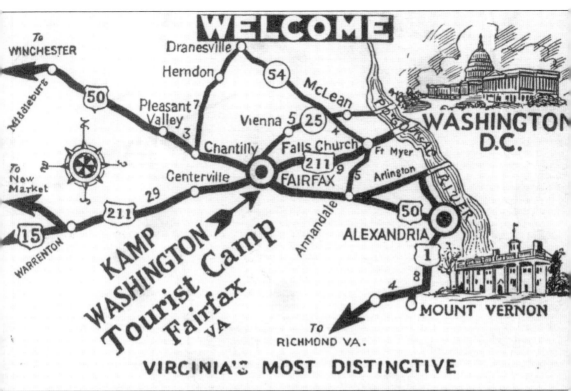

Located at Little River Turnpike and Lee Highway in the early 20th century, Kamp Washington provided tourists with heated and lighted cabins. Katherine Curry purchased the property in 1928. She, along with business partner and husband Warren Stoner, sold the property to Robert Conkle and Douglas Vincent in 1941. Albert Sherwood bought and redeveloped Kamp Washington in 1948. In 1928, the Kamp Washington cabins offered little more than a bed, a few chairs, a heater stove, and a single electric bulb. Toilets and showers were located in a cabin at the center of the tourist camp. When Albert Sherwood purchased the property in 1948, he built small brick houses in place of cabins, renting them to locals. Now the area offers a number of big box shops and smaller stores at, arguably, the town's busiest intersection. (Courtesy of the Fairfax Museum and Visitor Center.)

Before the area was known as Kamp Washington, locals called it the Black Lantern Inn after one of the area's landmarks. The Wells family operated the inn at the location of the shopping center currently located between Fairfax Boulevard and Lee Highway. More development of the area started in the late 1920s and early 1930s. New businesses popped up in that area, including the Colonial Inn and Stoner's Kamp Washington cabins. The cabins gave Kamp Washington its name. Eventually the Colonial Inn became the Spears restaurant. The Lord Fairfax Motel opened on a hill facing Lee Highway. The Virginia Diner was built closer to the intersection. Southern States Co. constructed a frozen food locker plant. It later became Weber Tire Co. Alton Poole operated a poultry processing business next to the Southern States locker plant. Murphy and Ames later opened a lumber company at the old poultry business. (Both, courtesy of Lee Hubbard.)

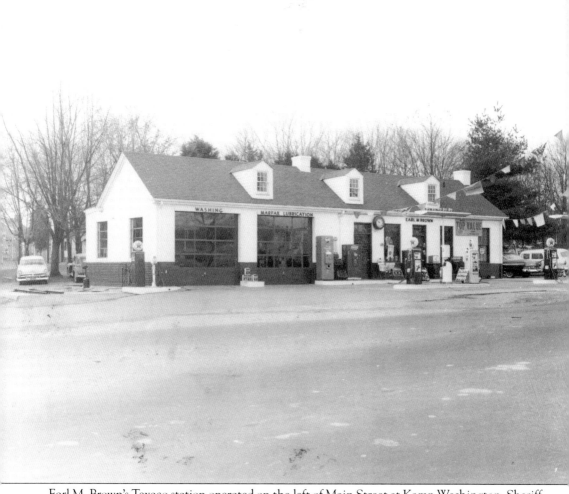

Earl M. Brown's Texaco station operated on the left of Main Street at Kamp Washington. Sheriff Eppa Kirby owned the Texaco station in the 1940s. This photograph shows the Texaco station in 1960. Albert Sherwood's house is shown in the background. The Sherwood house used to be a tourist home. It was moved from present-day Lee Highway and Fairfax Boulevard to Park Road in 1963. Earl Brown's brother Kenneth ran a Yellow Cab company and bail bonding business in Fairfax. Another of Earl Brown's brothers, Fred, served as the Virginia game warden for years. The Gillespie family owned another Texaco station at Old Lee Highway and Main Street starting in the 1920s. Texaco was one of a handful of companies serviced by the tank farm located on Pickett Road in the 1960s. (Courtesy of the Virginia Room, Fairfax County Public Library.)

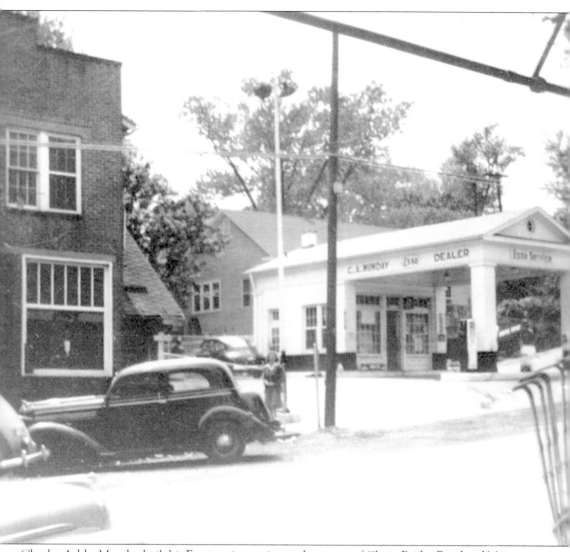

Charles Ashby Munday built his Esso service station at the corner of Chain Bridge Road and Main Street, the site of Young's garage in the 1930s. Munday, who hailed from Waxpool in Loudoun County, tore down his service station in the early 1950s and built the one still standing today. After Munday retired, his son, Eddie, ran the Esso business. The automobile garage built before on the site of the Esso service station was destroyed in 1929 by a fire that gutted the garage and threatened the Come Rite Inn restaurant and John W. Rust's law office. L.H. Young died before he saw his garage burn. The property was valued at about $14,000, according to a September 1929 article in the *Fairfax Herald*. (Courtesy of Lee Hubbard.)

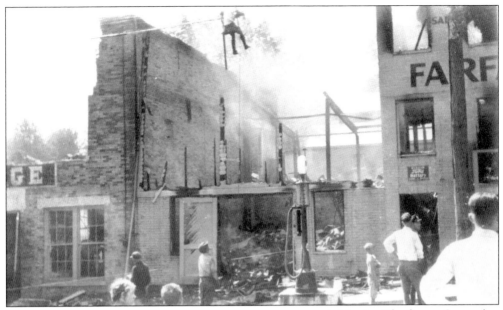

The fire on September 14, 1929, destroyed Fairfax Garage and threatened Come Rite Inn and the law office of John W. Rust. Destruction of the garage, owned by the estate of the late L.H. Young, was valued at about $14,000 according to the *Fairfax Herald*. (Courtesy of Lee Hubbard.)

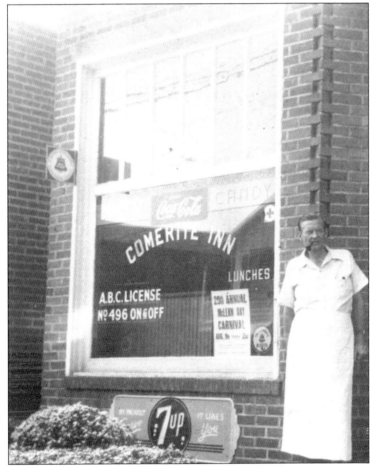

Come Rite Inn in downtown Fairfax offered families a place to sit down and enjoy a "meat and potatoes" meal. This restaurant was run by Elmer Dove and his wife, Martha, throughout the 1940s. Martha later worked as a cafeteria manager at the former Fairfax High School. (Courtesy of Lee Hubbard.)

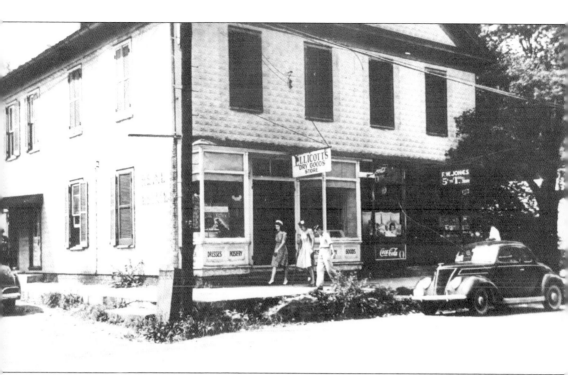

Charles Ellicott owned and operated a dry goods store on what is now known as University Drive in downtown Fairfax. That same building also housed Taylor's Pharmacy at another time. Ernest Robey's pharmacy was located in the same building before Ellicott's Dry Goods. Old Town Fairfax also served as home to a number of mom-and-pop shops. W.T. Ralston ran a meat market at the ground floor of the Willcoxon Tavern. Ralston moved his meat market to at least two different locations during its lifetime. Fairfax's first bank, the National Bank of Fairfax, got its humble start in downtown Fairfax in the old Fairfax County Clerk's Office. It later took up the space formerly occupied by Willcoxon Tavern and W.T. Ralston's meat market. The *Fairfax Herald* moved to two downtown Fairfax locations. It settled at the corner of Main Street and University Drive. (Courtesy of Lee Hubbard.)

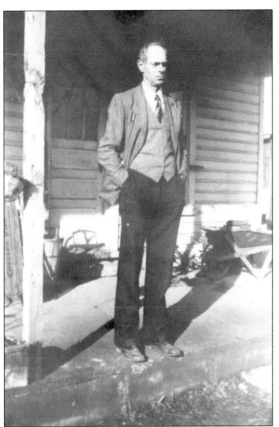

This photograph shows Frank Emanuel Jones standing on his porch on Jones Street, now known as Judicial Drive. Jones was born in the current area of the Breconridge development on Braddock Road. He owned a few acres on Jones Street, where he did a little farming, raised nursery stock, and ran a cider press from his small apple orchard. (Courtesy of Lee Hubbard.)

Ernest Robey owned a pharmacy in the same building where Taylor's Pharmacy and Ellicott's Dry Goods had been. The pharmacy was located on University Drive in downtown Fairfax. (Courtesy of Lee Hubbard.)

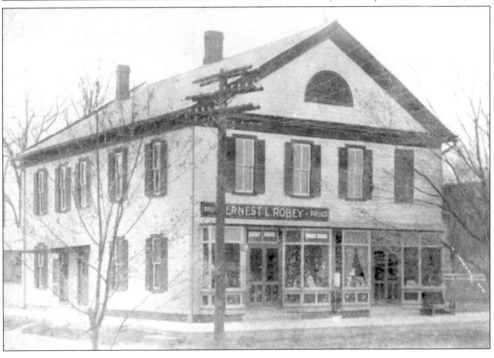

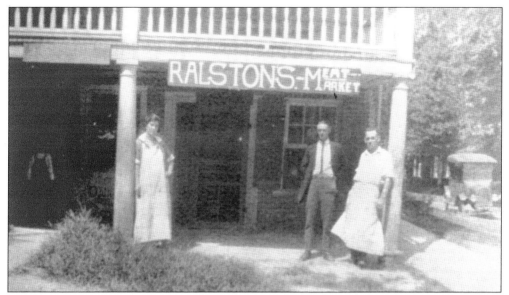

W.T. Ralston moved his meat market to at least two different locations during its lifetime. The above photograph shows it when it was located at the ground floor of the Willcoxon Tavern. Ralston is shown on the right with two other unidentified individuals. (Courtesy of Lee Hubbard.)

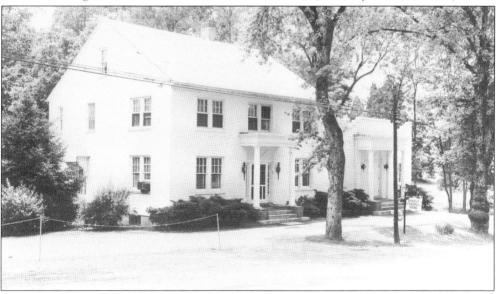

Opened in 1946, Everly Funeral Home became the second Everly firm in 150 years of funeral service. Josiah Stickley Everly opened his first funeral home, the Everly-Wheatley, in Alexandria in 1849. The company opened a third location in Falls Church in 1993. This photograph shows the Fairfax location in 1955. The same building housed the Groff Funeral Home in the 1930s and 1940s. The funeral home is located next to the historic Fairfax Cemetery, down the road from the Fairfax County Judicial Center. Everly's funeral homes serve customers of all religions and cultures. They offer burial services as well as cremation. The flagship funeral home in Alexandria is one of the largest in Northern Virginia. The Everly-Wheatley can fit 250 guests in its chapel. It is located near the Arlington National Cemetery. (Courtesy of the Virginia Room, Fairfax County Public Library.)

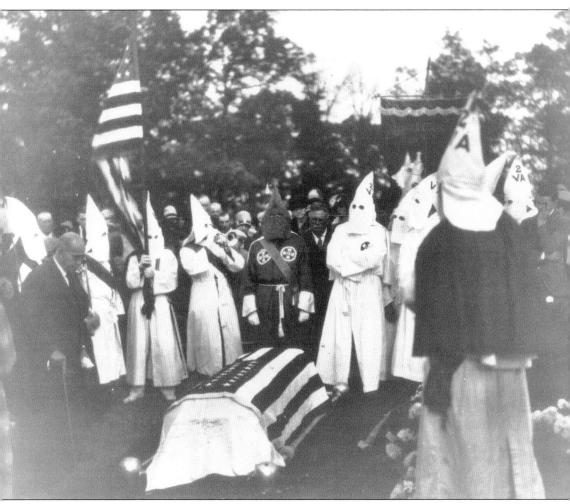

This photograph shows a Ku Klux Klan funeral at Fairfax Cemetery in 1927. In the 1920s, a local Ku Klux Klan group used the old Fairfax Elementary School, now the Fairfax Museum and Visitor Center, as a meeting place and headquarters for the KKK-published *Fairfax County Independent* newspaper. (Courtesy of the Virginia Room, Fairfax County Public Library.)

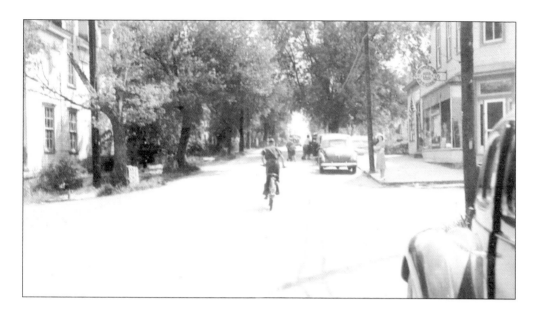

Longtime city of Fairfax resident Lee Hubbard recounts his time visiting Fairfax: "I was born and grew up in Fairfax Station. The Town of Fairfax was the place we went for major grocery shopping, banking. I would go there with my mother as a youngster so I remember Fairfax from a very early age. My cousin and I would ride our bikes or sometimes walk there to the Come Rite Inn for ice cream or hamburgers. Later when the Fairfax Theatre opened we went to the movies as often as we could. Everyone I encountered was friendly and always good to us." Hubbard now lives on Cleveland Street with his wife. These photographs capture Main Street in 1942. The top photograph shows the street looking east. The bottom photograph shows a westward view. (Both, courtesy of Lee Hubbard.)

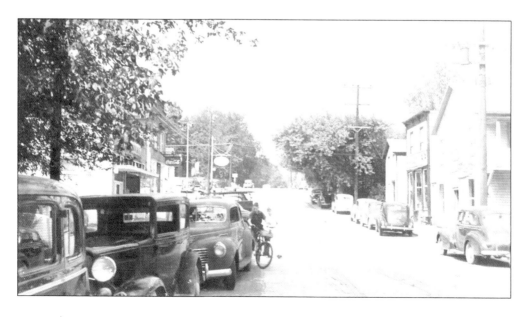

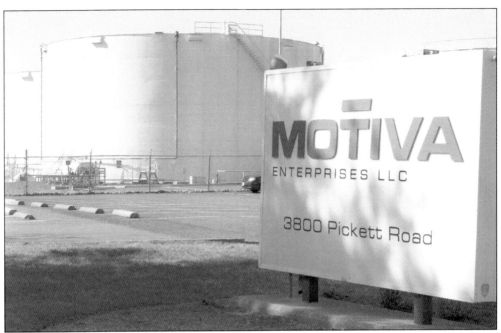

The Pickett Road tank farm was built in the 1960s as part of the Colonial Pipeline. Back then, it served Amoco, Citgo, Chevron, and Star/Texaco. Now it is owned and operated by Motiva Enterprises. The Colonial Pipeline moves about 100 million gallons of gasoline and other fuel a day. It stretches over 5,500 miles, delivering product by pipeline from Houston, Texas, to New York City. In 1990, an underground leak caused about 250,000 gallons of diesel oil, gasoline, and other chemicals to contaminate the surrounding neighborhoods, according to news reports. The cleanup cost hundreds of millions of dollars and troubled Fairfax and Mantua residents for years. (Both, courtesy of Whitney Rhodes.)

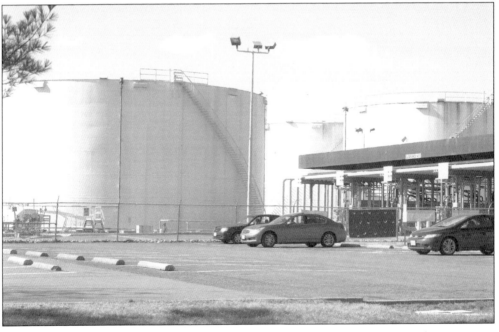

This little house stood at 10645 Main Street, just past the Fairfax Cemetery, since at least the early 1900s. L.H. Young rented the home before he built his house on Oliver Street. Mr. and Mrs. Stull later took up residence. This photograph shows the house being used as the Crescent Radio and TV shop in 1980. (Courtesy of the Virginia Room, Fairfax County Public Library.)

The former Young residence and Crescent Radio shop was eventually demolished to make way for the PNC bank on Main Street east of Judicial Drive. (Courtesy of Lee Hubbard.)

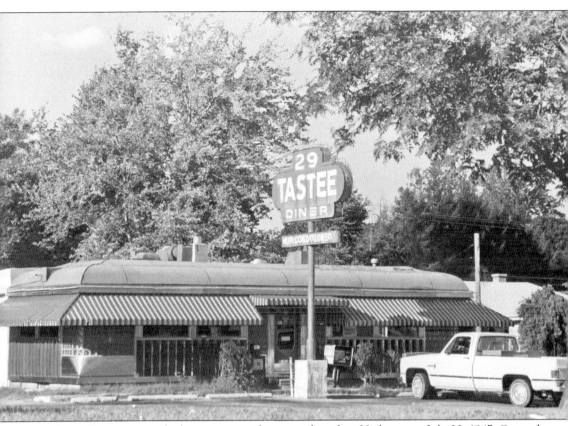

The 29 Diner was trucked to its current location along Lee Highway on July 20, 1947. Created by the Mountain View Diner Company of New Jersey, the roadside eatery was rare in Northern Virginia. The Mountain View Diner Company, founded by Les Daniel and Henry Strys, stopped operating in 1957. The 29 Diner still serves breakfast and diner staples amid car dealerships on the same street, now named Fairfax Boulevard. This photograph of the diner was taken in 1986. It remains one of a few modern streamline diners in the nation. The diner boasts steel and tile construction, rounded glass corners, and a look that resembles a railroad car. Delmas T. Glascock first owned the 29 Diner. Leonard Milliken, the current owner of the diner, changed its name from the 29 Diner to the Tastee 29 Diner in 1973. (Courtesy of the Virginia Room, Fairfax County Public Library.)

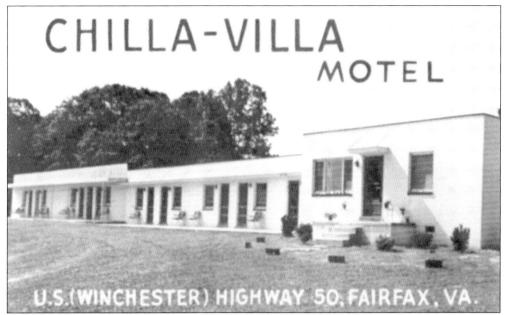

Chilla Villa was one of many flashy hotels lining Route 50 in Fairfax in the early 20th century. This postcard image promotes Chilla Villa with the following message: "New and extremely modern. Mr. and Mrs. P.E. Myers and Donald Myers, owners and operators." Neighboring hotels were named Sunset Grove Cottages, the Breezeway Motel, the Anchorage Hotel, and the Hy-Way Motel. (Courtesy of the Fairfax Museum and Visitor Center.)

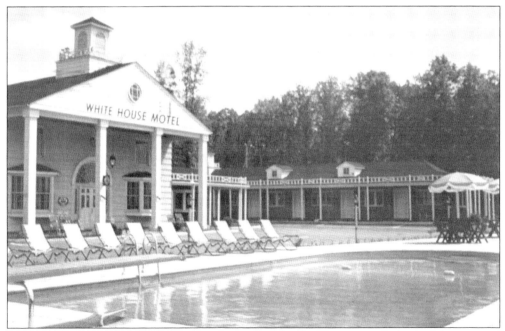

The White House Motel stood on Lee Highway around 1950. The text on the back of this postcard boasts air-conditioned motel units, a swimming pool, and a telephone in each room. (Courtesy of the Fairfax Museum and Visitor Center.)

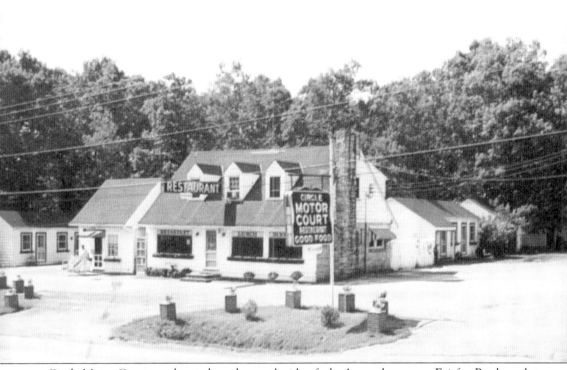

Circle Motor Court was located on the north side of what's now known as Fairfax Boulevard at Fairfax Circle. The court was a development meant for travelers. It offered a motel, restaurant, and gas station. The back of the postcard boasts "Simmons beds and mattresses. Modern steam heated cottages with connecting garage. Complete one-stop service. Dining room and service station. 14 miles west of Washington, DC." (Courtesy of the Fairfax Museum and Visitor Center.)

Three

HISTORIC FAIRFAX

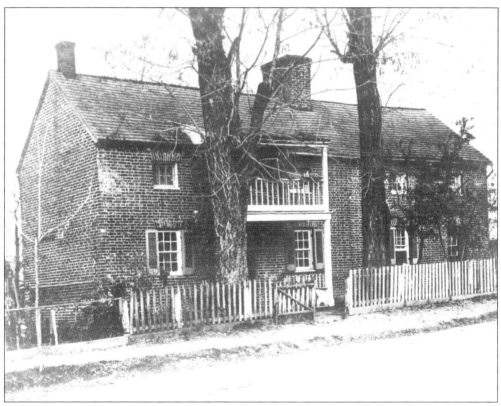

The oldest residence in the city of Fairfax, the Ratcliffe-Allison House now serves as a museum memorializing the lives of its many owners throughout the history of the city. It was built in 1812 by Fairfax founder Richard Ratcliffe when Fairfax was known as the town of Providence. This photograph shows a front view of the house in the early 20th century. (Courtesy of the Virginia Room, Fairfax County Public Library.)

Kate Waller Barrett, a social reformer, and daughter Kitty Pozer, of gardening fame, were the last to own the Ratcliffe-Allison House. Dr. Kate Waller Barrett's Florence Crittenden Foundation purchased the house in the 1920s to save it from being torn down for a garage. The City of Fairfax received the deed to the old house in 1973, thanks to a dedicated citizens committee, a handful of city of Fairfax residents, and historians who suggested the transaction. Kitty Pozer gave the building and front portion of the property to the city for free. The city purchased the remaining rear 80 percent of the historic property, 19,440 square feet extending to North Street, for $77,760, according to the *Fairfax Herald*. This photograph shows the inside second floor and door of the Ratcliffe-Allison House. The photograph was taken from the west room looking southeast. (Courtesy of the Library of Congress.)

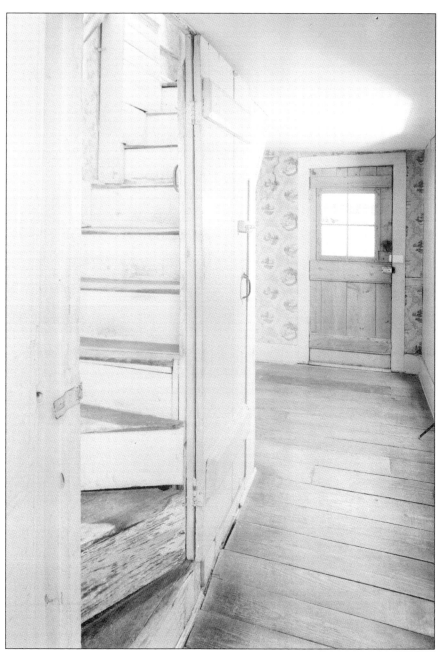

Now, the house-turned-museum offers a detailed look at the lives of 12 locals who owned the property. These exhibits allow visitors to catch a glimpse of what was like for families living in the same home in the same town but during different eras. This photograph shows the inside of the Ratcliffe-Allison house entrance hall and winding staircase. The house was added to the National Registry of Historical Places in 1973. Richard Ratcliffe built the east side of the building, the oldest portion of the house. On January 14, 1805, several years before the construction of the Ratcliffe-Allison House, the Virginia General Assembly permitted the area near the Fairfax County Courthouse to be named the town of Providence. State officials gave the charter for the town of Providence to Ratcliffe. (Courtesy of the Library of Congress.)

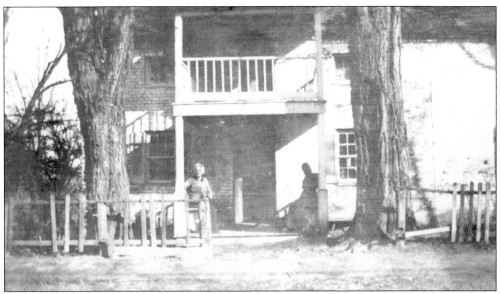

Mrs. Richardson and her sister stand on the porch of the Ratcliffe-Allison House in 1875. It is the oldest residence in the city of Fairfax. (Courtesy of the Virginia Room, Fairfax County Public Library.)

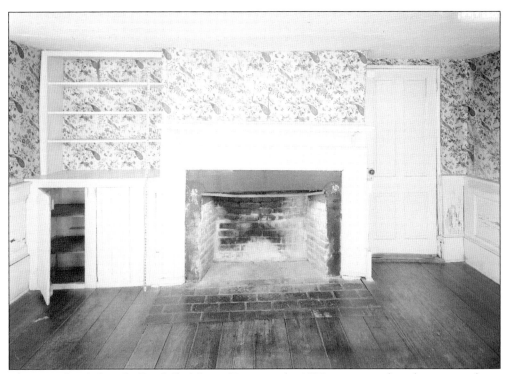

The Pozer family bought Ratcliffe-Allison House in the 1920s to save it from being torn down for a garage. This photograph shows the preserved interior of the home in 1995. The photograph was taken on the first floor in the house's center room. It depicts the west wall elevation with fireplace and mantel. (Courtesy of the Library of Congress.)

A citizens committee was later formed to brainstorm a future for the building. The committee consisted of former mayor George A. Hamill, chamber of commerce president W.R. Bender, Will H. Carroll, C. Barrie Cook, Edith Elliott, Carol Heflin, Richard O'Keeff, and Jeanne Rust. Kitty Pozer, with the recommendation of the citizens committee, gave the Ratcliffe-Allison House to the City of Fairfax as a gift in 1973. These photographs show the preserved interior of the home in 1995. (Both, courtesy of the Library of Congress.)

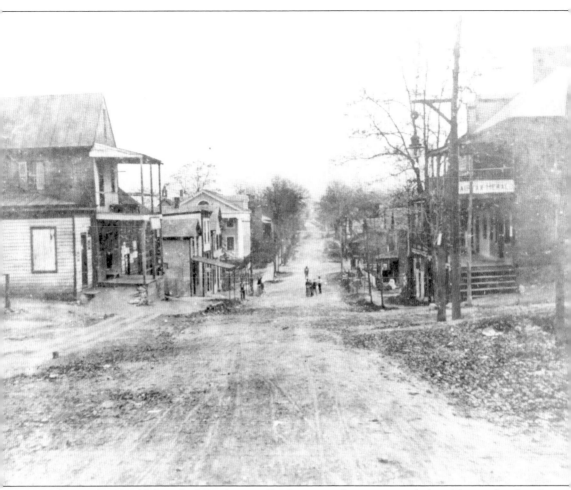

The *Fairfax Herald* described Fairfax as a "little city in the country inhabited by a refined and hospitable people and surrounded by thrifty, well-tilled farms." This photograph shows the main dirt street through downtown Fairfax. The *Fairfax Herald* office is visible on the right. The *Fairfax Herald* operated from 1882 to 1966 at the corner of Main Street and Chain Bridge Road. It was later moved to Main Street and University Drive. Capt. S.R. Donohoe started the local newspaper. Roszel Donohoe worked as the editor for a time. S.R. Donohoe's daughter, Mary LeGrand (Donohoe) McCandlish, lived in the Moore-McCandlish house after R. Walton Moore, a member of the US House of Representatives and assistant secretary of state in Pres. Franklin D. Roosevelt's administration. (Courtesy of the Fairfax Museum and Visitor Center.)

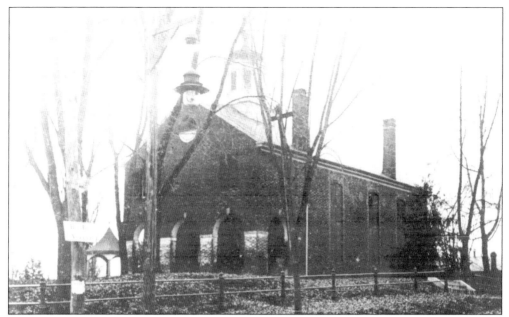

The Fairfax County Courthouse helped create the city of Fairfax residents know today. Court business drew men and their families to the area around the courthouse. Churches sprang up to solidify the community around the courthouse. The town of Fairfax grew out of wilderness and farmland in the late 1800s. This photograph looks at the Fairfax County Courthouse from the northeast in 1900. (Courtesy of the Virginia Room, Fairfax County Public Library.)

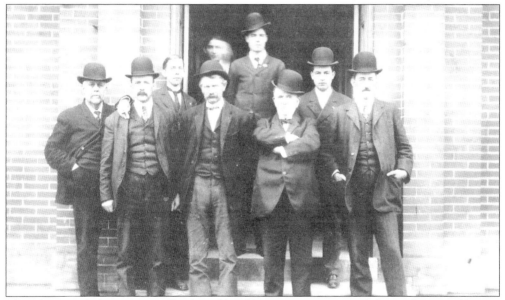

This photograph shows court officials and local lawyers in 1910. From left to right are William E. Graham, deputy court clerk; Sheriff J.R. Allison; Elton R. Holbrook, deputy court clerk; William D. Cross (front row center) deputy sheriff; John Rust, attorney (blurred in back); Archie Wells, deputy sheriff (tallest in center back); F.W. Richardson, clerk of the court (front row with arms crossed); Dick Farr, attorney; and R. Walton Moore, attorney, US Congressman, and eventual assistant secretary of state. (Courtesy of Lee Hubbard.)

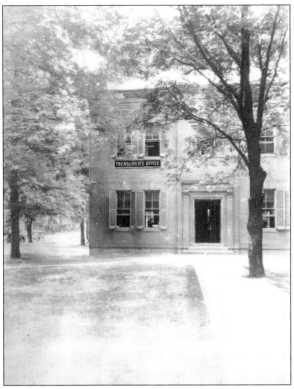

Fairfax County purchased four acres of land near the center of the county in 1799 for $1 from Richard Ratcliffe. The lot was later expanded to 10 acres to provide enough room for a jail, gallows, clerk's office, and other buildings. This photograph shows the Fairfax County Treasurer's Office on the Fairfax County Courthouse property on August 1925. (Courtesy of the National Archives.)

This photograph shows the Fairfax County Courthouse well and livery stables in 1905. The courthouse underwent several phases of renovations and additions. (Courtesy of the Virginia Room, Fairfax County Public Library.)

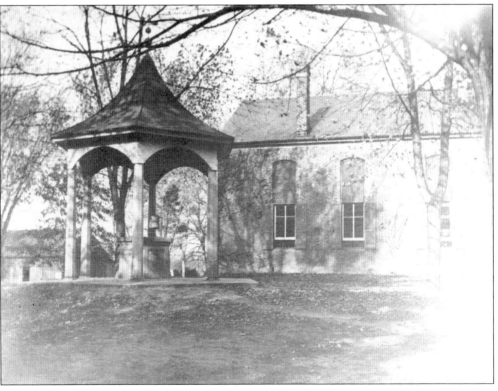

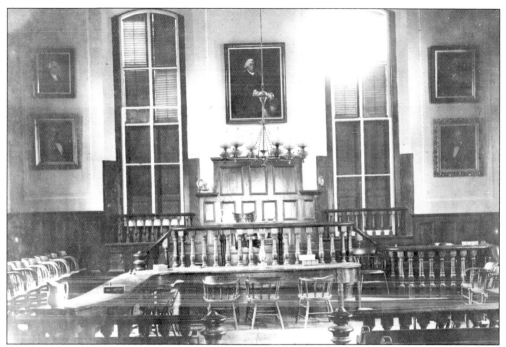

Fairfax County Court started in 1742 in Spring Fields, a location just southwest of Tysons Corner. The county added a second courthouse in Alexandria in 1752. "Gentlemen justices" like George Washington and George Mason set tax rates, approved roads, and licensed ordinaries. In 1790, Fairfax County ceded some of its land and decided to build a new county courthouse in a more central location. The first session at Fairfax Court House was held on April 21, 1800. (Courtesy of Lee Hubbard.)

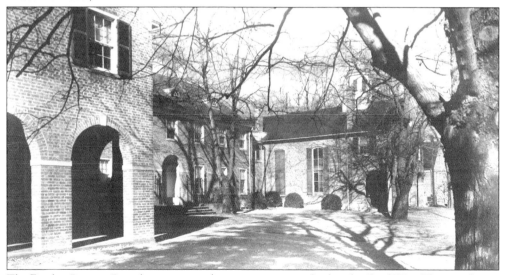

The Fairfax County Courthouse received reconstruction work after the Civil War. The courthouse underwent more renovations in the early 20th century. Courthouse rooms were upgraded with electric lights in 1918, a renovated courtroom in 1920, and an addition in 1929. This photograph shows the old wing of the courthouse in 1965. (Courtesy of the Virginia Room, Fairfax County Public Library.)

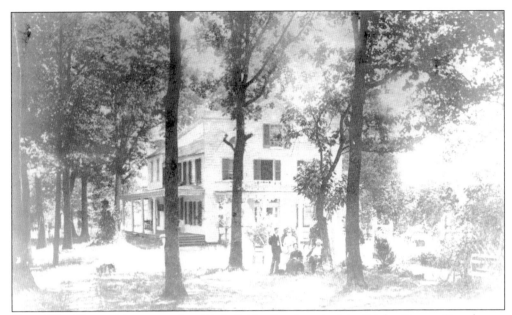

Henry Wert Thomas's house stood on Chain Bridge Road south of the Fairfax County Courthouse. Thomas practiced in a Fairfax law office in 1842. He was later appointed to finish out a term as lieutenant governor of Virginia. Col. H.W.T. Eglin, Thomas's grandson, fought in World War I and helped start the VFW in Fairfax. This photograph shows the Thomas House with Judge and Mrs. Thomas in front in the 1880s. (Courtesy of the Virginia Room, Fairfax County Public Library.)

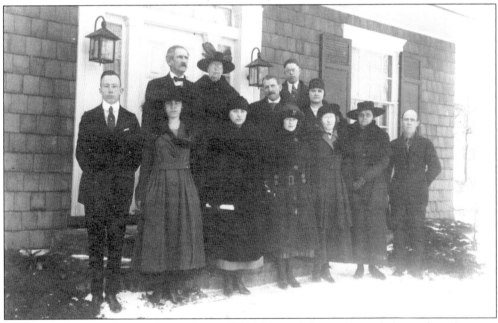

This group photograph was taken in front of Dr. Moncure's house, located almost directly across Chain Bridge Road from the old Methodist church. Shown above from left to right are (first row) Wesley Israel, Viola Kidwell, Mabel Sauls, Leighton, Edna Jerman, Mrs. Moss Holbrook, Albert Franklin Kidwell; (second row) Reverend Thrasher, Mary Lee Whalen, H.B. Derr, and John and Florence Whalen. (Courtesy of Lee Hubbard.)

This photograph, taken in 1915, shows the home of Virginia senator John W. Rust. Rust's son, John H. Rust, served as mayor of Fairfax in 1941 and worked as an attorney for the city until 1947. His grandson, John H. Rust Jr., went on to practice law at the Rust and Rust firm in Fairfax and served on the Historical Fairfax, Inc., board of directors. (Courtesy of the Virginia Room, Fairfax County Public Library.)

Virginia senator John W. Rust stands in front of his office across from the Fairfax County Courthouse on Chain Bridge Road in 1910. Three generations of the Rust family have worked in this Rust and Rust law office. (Courtesy of the Virginia Room, Fairfax County Public Library.)

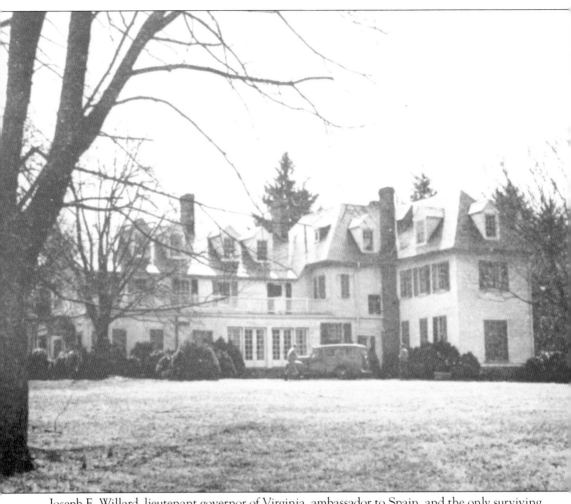

Joseph E. Willard, lieutenant governor of Virginia, ambassador to Spain, and the only surviving son of Antonia Ford Willard, built Layton Hall in 1893 on a 10-acre parcel next to Dunleith (Thomas Love's property). Six years later, he acquired another 10-acre parcel on the other side of Dunleith, the Gunnell property. Willard purchased the Dunleith property in 1899, after Thomas Love's death. He then owned a massive chunk of land just to the side of the current downtown Fairfax. In 1923, Willard sold Layton Hall the Fairfax Development Corporation. It was later sold to the Willard Development Corporation. Willard and his wife, Belle Layton Wyatt Willard, passed on, and the massive property was divided to form the Joseph Willard Health Center, Layton Hall subdivision, City of Fairfax Regional Library, Fairfax Post Office, Belle Willard School, Layton Hall Apartments, Old Fairfax Mews, Courthouse Plaza Shopping Center, Democracy Office Park, and more. (Courtesy of Lee Hubbard.)

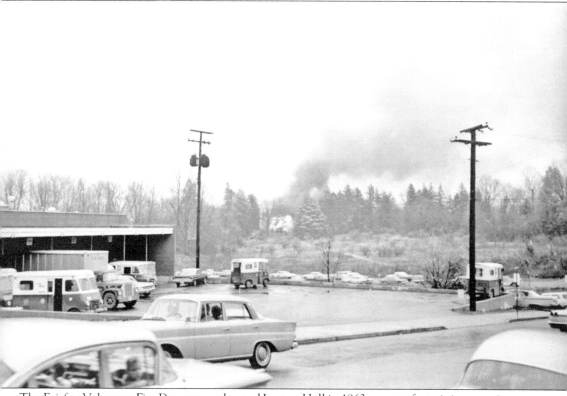

The Fairfax Volunteer Fire Department burned Layton Hall in 1963 as part of a training exercise. This photograph shows smoke rising over the former Willard property on December 14, 1963. The photograph was taken from the corner of North Street and Chain Bridge Road from behind the Fairfax Post Office. Union major Joseph C. Willard purchased the Willard Hotel in Washington, DC, with his brother, Henry A. Willard. He became the sole owner of the DC hotel after buying his brother's interest in 1892. Willard, the jailer of alleged spy Antonia Ford, married his prisoner in 1864 after her seven-month prison term. Ford died in 1871. Willard never remarried and died in 1897. His only surviving son, Joseph E. Willard, married Belle Layton Wyatt and built Layton Hall in 1893. He became a member of the Virginia House of Delegates and served as lieutenant governor of Virginia and ambassador to Spain. (Courtesy of Lee Hubbard.)

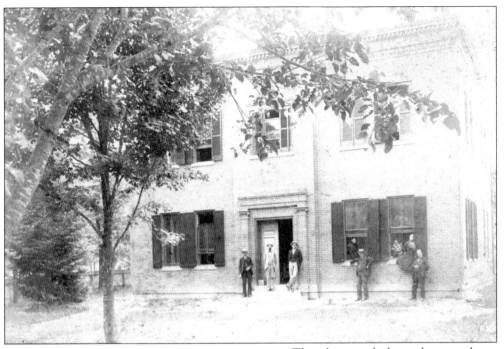

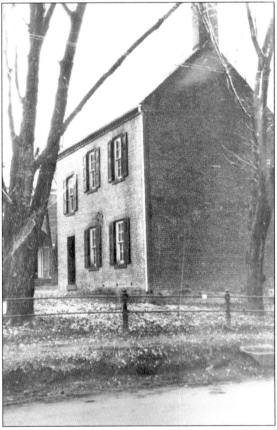

This photograph shows the second location of the Fairfax County Clerk's Office. Standing in front of the office are Bob Allison (left), Robert Wiley (in door), Jim Graham (center), unidentified, Mrs. Graham (in the window), and J.W. Richardson (right). The office moved several times during its lifetime. (Courtesy of Lee Hubbard.)

The first clerk's office stood on the courthouse grounds about at the intersection of Chain Bridge Road and Sager Avenue. It was moved to its second location in 1881, then into the Fairfax County Courthouse when an addition to the property was completed in 1929. The old clerk's office location was where the National Bank of Fairfax started in 1902. (Courtesy of Lee Hubbard.)

In 1887, Fairfax locals could stop by a telephone office in the Fairfax County Courthouse to send messages. There people could contact offices in Alexandria, Annandale, Centreville, Gainesville, Haymarket, and Thoroughfare. It cost 15¢ to send a message to Alexandria and 10¢ for any other destination. Incoming messages were free. The first phone in Fairfax was installed at the Willcoxon Tavern. This photograph shows the tavern in 1930. (Courtesy of the Virginia Room, Fairfax County Public Library.)

This undated photograph shows a Willcoxon Tavern overmantel, along with Ed Campbell and Douglas Walters. The overmantel was later moved to Col. Francis P. Miller's study in Kitty Hawk, North Carolina. Willcoxon Tavern was a long-standing historic landmark in downtown Fairfax. (Courtesy of the Virginia Room, Fairfax County Public Library.)

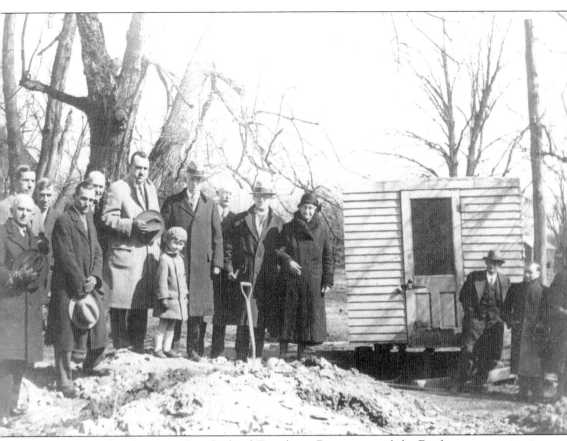

The Falls Church's rector, Rev. Richard Templeton Brown, started the Fairfax congregation in 1843. They first met in Mrs. William Rumsey's home, then built Zion Church on the current-day Truro Anglican Church property in 1845. The congregation abandoned it during the Civil War. Zion Church was destroyed during the war. When they returned, they rebuilt the church and used it until 1933, when a new church was built. It was consecrated as Truro Episcopal Church in 1934. Brown kept a Truro Church rectory at Fairfax Cemetery to the east until he sold it to the Fairfax Ladies Memorial Association in 1866. That land was used as a burial site for Fairfax Confederate soldiers. Coombe Cottage was located next door to the future site of the church. The cottage served as a boarding school for young women from 1844 to 1863. The school was located on Little River Turnpike, now known as Main Street. (Courtesy of Lee Hubbard.)

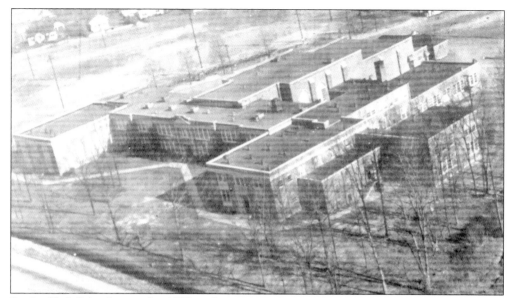

Fairfax High School opened in 1935 on the property that now holds Paul VI Catholic High School, the first four-year consolidated high school in Fairfax County. City of Fairfax school officials moved the high school to a new building on Old Lee Highway in 1972. The school property was upgraded to the tune of $54 million in 2007. This photograph shows Fairfax High School at its old location. (Courtesy of the Fairfax Museum and Visitor Center.)

The Sherwood Home was finished in 1937 near Lee Highway and Fairfax Boulevard. It featured a solid wood banister crafted from a tree Albert Sherwood planted as a child. Sherwood ran a construction company and built numerous homes and a firehouse in Fairfax. He served on the Fairfax Town Council from 1916 to 1956. The home was moved to Park Road in 1963. (Courtesy of the Virginia Room, Fairfax County Public Library.)

Robert Lewis Sisson's family had lived in Fairfax since his grandfather, Robert Sisson, settled there in 1782. His father, Robert Townsend Sisson, was one of the original deacons of the Jerusalem Baptist Church when it was organized in 1840 in the abandoned Payne's Church. The Sisson House was sold by his daughter, Lillie Perry. Now located next to city hall, it is used as the office of the City of Fairfax schools superintendent, electoral board, and registrar of voters. (Courtesy of Whitney Rhodes.)

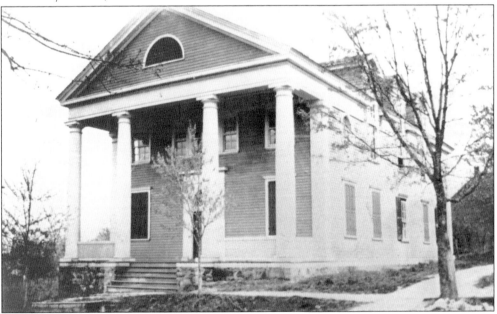

Located at the corner of Main Street and University Drive, the town hall serves as a social center and architectural wonder. Old Town Hall hosts annual city events like the Chocolate Lovers Festival and is open to wedding reservations. The building boasts neoclassical architecture with Tuscan-order columns and Federal-style details. (Courtesy of the Virginia Room, Fairfax County Public Library.)

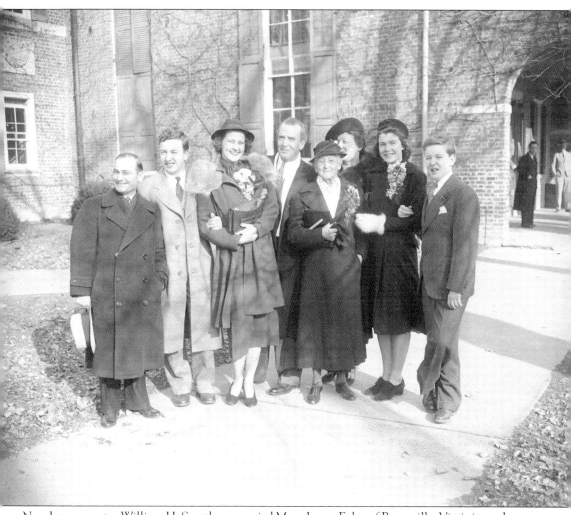

New Jersey senator William H. Smathers married Mary James Foley of Berryville, Virginia, at the Fairfax County Courthouse on February 9, 1938. Shown in the photograph from left to right are Fred Yale of New Jersey, Joseph B. Smathers, Mary James Foley, William H. Smathers, Mrs. B.F. Smathers, Mrs. William Abbott Coleman, Billie Smathers, and Benjamin F. Smathers. (Courtesy of the Library of Congress.)

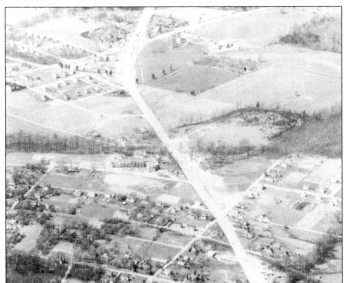

This aerial image illustrates a vastly different city of Fairfax than that known today. In the early to middle of the 20th century, Fairfax changed from farmland to a suburb of Washington, DC. The photograph at left shows the area around Fairfax High School, Kamp Washington, and the Fairfax Race Track in 1950. (Courtesy of the Virginia Room, Fairfax County Public Library.)

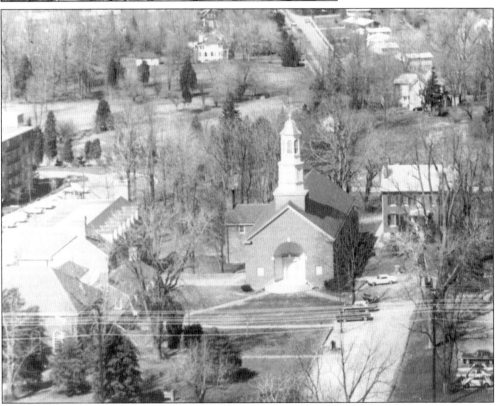

Fairfax grew rapidly in the middle of the 20th century. The area saw an almost 700-percent increase in residents during the 1950s. By the early 1970s, Fairfax was home to 22,700 people. New businesses sprang up in downtown Fairfax and along Lee Highway. The Fairfax Court House locale became an independent city in 1961. This photograph shows an aerial view of businesses and neighborhoods surrounding Truro Episcopal Church in 1965. (Courtesy of the Virginia Room, Fairfax County Public Library.)

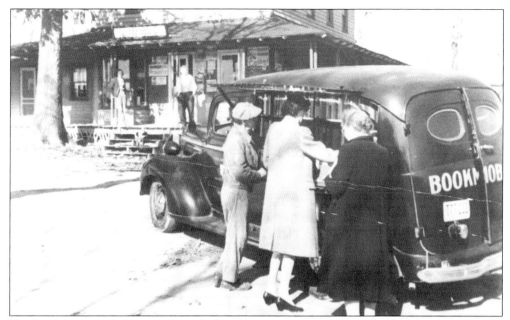

Fairfax County started a countywide free library system in 1939. The library system used a bookmobile to move materials to the public. The Chevrolet truck's side panels opened to give access to about 600 books. Now Fairfax County Public Library's digital bookmobile promotes the eAudiobook and eBook download service. Anyone with a library card can access materials from the FCPL website. (Courtesy of the Virginia Room, Fairfax County Public Library.)

A $2-million library bond allowed the humble Fairfax County library system to build a headquarters in Fairfax and open six library branches throughout the county. The headquarters housed the system's prized Virginia Room, a collection of historical photographs and documents charting the region's birth and growth. The Fairfax library closed temporarily in May 1983 for remodeling, as shown in the photograph at right. It moved to North Street and Old Lee Highway in February 2008. (Courtesy of the Virginia Room, Fairfax County Public Library.)

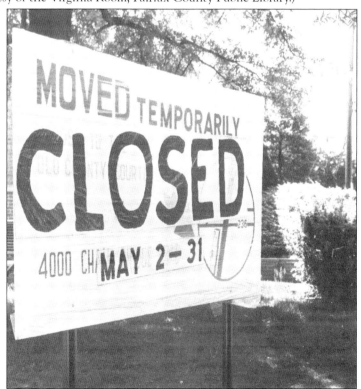

Construction of the new city hall building started after July 1961 and was completed in 1962, after the city of Fairfax became its own independent city. City hall now houses the city's general district court, city manager's office, clerk's office, commissioner of the revenue, finance department, treasurer, and other city employee offices. (Courtesy of the Virginia Room, Fairfax County Public Library.)

City of Fairfax government employees moved into the new city hall building at South Payne, now George Mason Boulevard, and Armstrong Streets on August 20, 1962. This photograph shows the amphitheater next to city hall. (Courtesy of the Virginia Room, Fairfax County Public Library.)

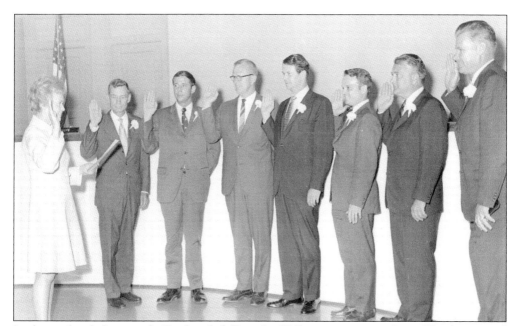

In this undated photograph, Fairfax clerk Dorothy Wilkinson swears in City of Fairfax council members at city hall. From left to right are Wilkinson, John W. Russell, Warren Davis, Rembert Simpson, George Hamill, two unidentified, and Theodore F. Grefe. (Courtesy of the Fairfax Museum and Visitor Center.)

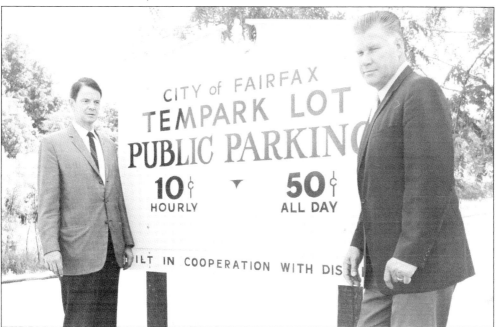

George Hamill (left) and Theodore F. Grefe (right) stand on either side of a new sign indicating a temporary parking lot in the city of Fairfax. The parking lot allowed drivers to park for 10¢ an hour or 50¢ for the full day. Today, downtown Fairfax offers a handful of paved and temporary parking lots in addition to a parking garage along Chain Bridge Road. (Courtesy of the Fairfax Museum and Visitor Center.)

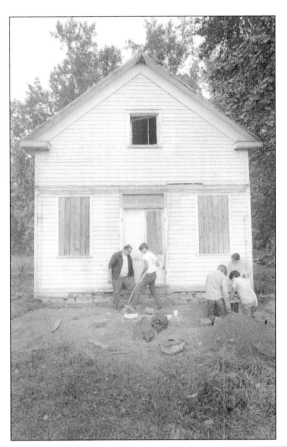

Hailed as the last of the one-room schools in Fairfax County, the Legato School is prepared by Tony P. Wreuer and his students for its relocation to downtown Fairfax. The school used to stand on the south side of Lee Highway, where present Pheasant Ridge Road intersects Lee Highway east of the Fairfax County Parkway. (Courtesy of the Virginia Room, Fairfax County Public Library.)

Students in first to eighth grade studied in this one-room schoolhouse from 1877 to 1930, when Legato School closed and the students were enrolled in Centreville. Now Fairfax County Retired Educators maintains and operates the school at its new location at the Fairfax County Judicial Center on Chain Bridge Road. (Courtesy of the Virginia Room, Fairfax County Public Library.)

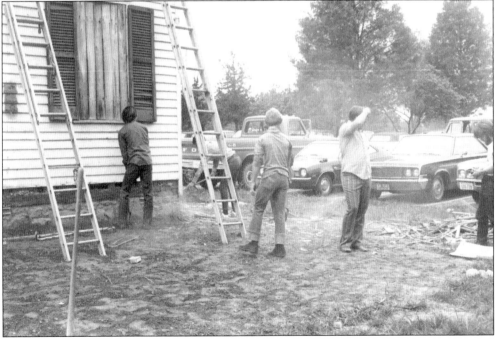

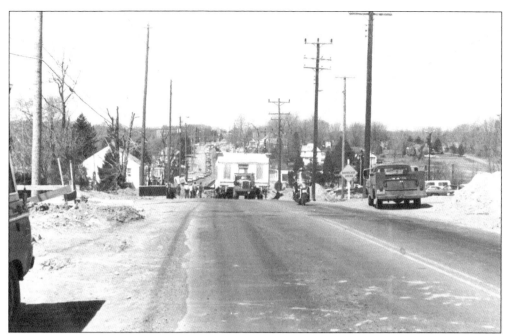

The Fairfax County School Board decided to restore and relocate the Legato School in 1969 as part of Virginia's 100th anniversary of public education. Legato crawled down Fairfax streets to its final Fairfax County Judicial Center location in March 1971. (Courtesy of the Virginia Room, Fairfax County Public Library.)

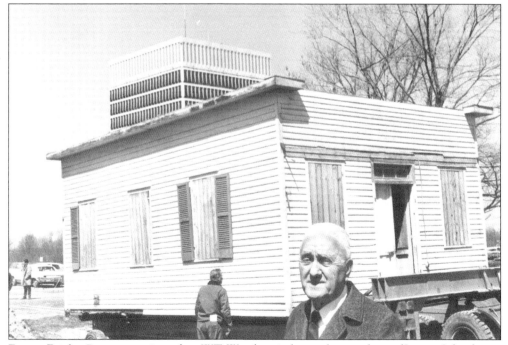

Former Fairfax County superintendent W.T. Woodson is shown above in front of Legato School in its new location in Fairfax. The school is now located along Chain Bridge Road in front of the Fairfax County Judicial Center. (Courtesy of the Virginia Room, Fairfax County Public Library.)

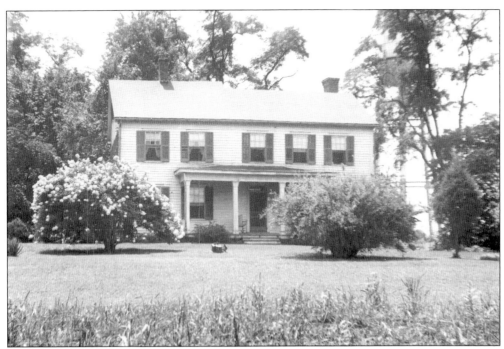

High Offley House was demolished to make room for the Massey Building in the Fairfax County Judicial Center in 1967. The judicial center moved Fairfax County's court proceedings a short way down Chain Bridge Road. Finished in 1982, the center houses the Fairfax Circuit and District Courts, Sheriff's Office, and Adult Detention Center. The Massey Building holds the police and fire departments. (Courtesy of the Virginia Room, Fairfax County Public Library.)

Carlton Massey, the first Fairfax County executive, is shown standing in front of the building named after him in 1968. Massey, namesake of the Massey Building in the Fairfax County Judicial Center in Fairfax City on Chain Bridge Road, worked as the executive from 1952 to 1971. (Courtesy of the Virginia Room, Fairfax County Public Library.)

The Fairfax County Courthouse underwent more renovations and additions in the 1950s. By then, the judicial needs of the region had changed dramatically since its pre–Civil War and rural years. After the county moved its judicial center farther south on Chain Bridge Road, officials sought funding to return the courthouse to its initial form and preserve its history. This photograph shows the Fairfax County Courthouse as it appears today. (Courtesy of the Virginia Room, Fairfax County Public Library.)

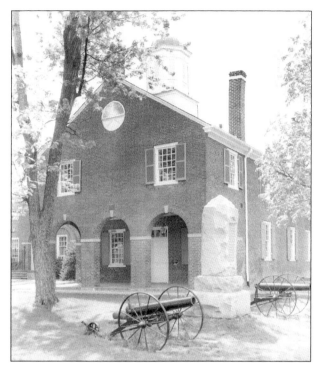

Thanks to petitioning from the Fairfax County Bar Association and the Fairfax County Landmarks Preservation Commission, the Fairfax County Board of Supervisors agreed in the 1960s to restore the old courtroom in the Fairfax County Courthouse. The $90,000 project was completed in 1967, as shown in this photograph. (Courtesy of Lee Hubbard.)

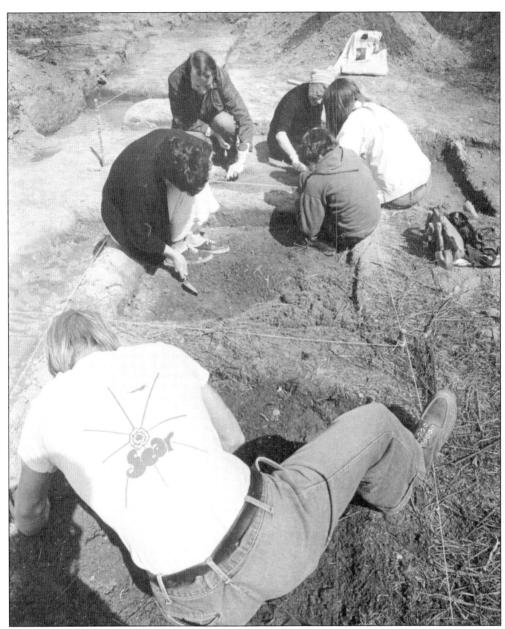

This photograph shows Jim Sorenson, Virginia Peters, Karen Hollerman, Matthew Bram and his mother, and Chris Quell digging for artifacts at the Fairfax County Courthouse in 1975. In addition to its use as the seat of Fairfax's governing officials, the Fairfax County Courthouse was occupied by the Central Farmers Club for its first Farmers Institute and Exhibition in 1891. The Fairfax County Courthouse is now preserved as a national historical place, though courthouse additions and some of the original buildings are still used as ancillary offices for the Fairfax County Circuit and District Courts as well as the county's juvenile and domestic relations department. The site was also used to host circuses, weddings, tournaments, celebrations, and even Quaker sermons. In 1976, officials buried a time capsule next to the original front wall of the courthouse with instructions not to open it until 2076. (Courtesy of the Virginia Room, Fairfax County Public Library.)

Fairfax County officials gathered at the Fairfax County Courthouse in 1976 to place the National Register of Historical Places plaque, as shown in the photograph at right. Shown from left to right are an unidentified man, Jack Herrity, chairman of the Fairfax County Board of Supervisors; Bayard Evans, former chairman of the Historic Landmarks Preservation Commission; Edith Sprouse, chairwoman of the History Commission; Judge James Keith, clerk of courts; James Hoofnagle, former president of Fairfax County Bar Association; and C. Douglas Adams, president of the Fairfax County Bar Association. The bottom photograph shows the old Fairfax County jail and 1936 addition. (Both, courtesy of the Virginia Room, Fairfax County Public Library.)

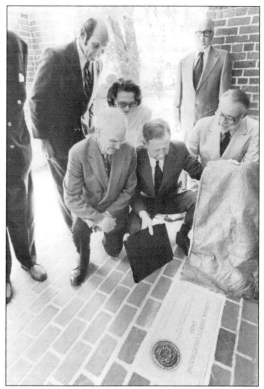

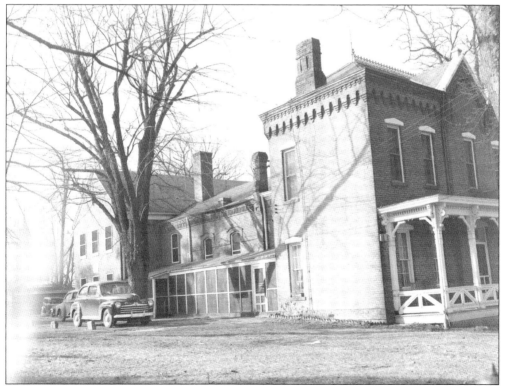

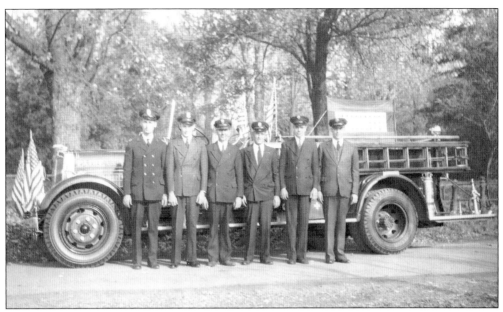

This photograph shows, from left to right, Marcel Pfalsgraf, Myron Cupp, Harry Riggles, Roy Hollis, Carlos France, and Gordon Dennis of the Fairfax Volunteer Fire Department standing in front of an old ladder fire truck. (Courtesy of Lee Hubbard.)

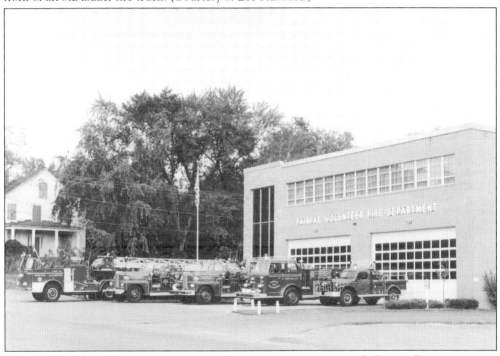

This photograph shows Engine 3, a 1959 Pirsch; Wagon 3, a 1965 Pirsch; Rescue Engine 3, a 1969 Pirsch; (1,250 gallons per minute); 3-9, a 1967 Dodge Power Wagon (300 gallons per minute, 120 gallons); and Truck 3, a 1963 Maxim (85-foot aerial). At the time of this photograph, Truck 18, a 1969 Seagrave (100-foot aerial), was temporarily relocated at Company 3. (Courtesy of the Virginia Room, Fairfax County Public Library.)

Hurricane David started eight tornadoes from Fairfax County to Newport News as it swept up the East Coast. On September 5, 1979, one of those tornadoes touched down in Fairfax, causing $2 million in damage. This photograph shows the aftermath of the twister at Williamsburg Square. (Courtesy of the Virginia Room, Fairfax County Public Library.)

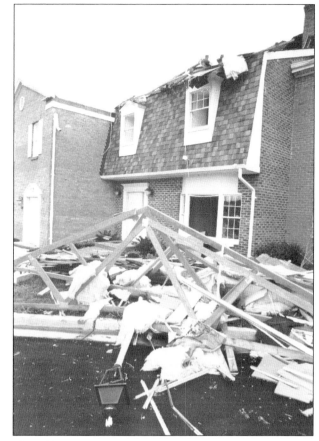

This photograph shows a flipped vehicle and building destruction at Williamsburg Square in Fairfax on September 5, 1979. That same tornado cut a swath of destruction in the area. It lifted, only to reach the ground again in Great Falls. (Courtesy of the Virginia Room, Fairfax County Public Library.)

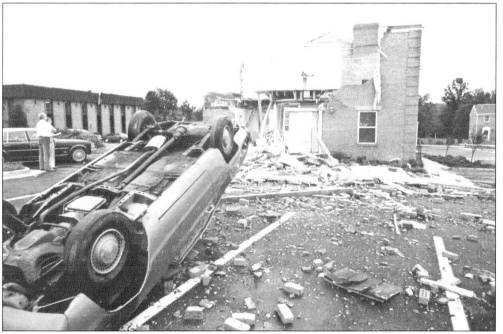

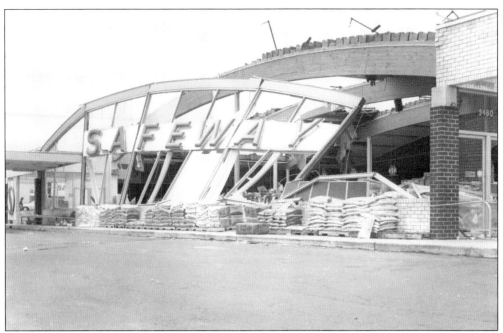

Another tornado on April 1, 1973, tore open this Safeway grocery store on Pickett Road. Fairfax County Police took this photograph of the destruction a day after the tornado touched down in the city of Fairfax. The tornado also damaged Woodson High. (Courtesy of Lee Hubbard.)

This photograph shows the original Fairfax County Courthouse with its 1929 addition. The addition extended the courthouse building by adding a wing on the side of the structure. Another addition in 1953 completed the courthouse's E shape. (Courtesy of Lee Hubbard.)

James Roberdeau "Bob" Allison served as sheriff of Fairfax from 1904 until he died in 1927. Allison married Nora Wynkoop, daughter of Albert K. Wynkoop and Nancy Stone, on July 5, 1905. This photograph was taken around 1927. (Courtesy of Lee Hubbard.)

This photograph shows the trial justice building, which also served as the Fairfax County Police headquarters. It stood where the large center section of the Fairfax County court complex stands now. The trial justice building was built in the early 1930s and torn down in 1952. (Courtesy of Lee Hubbard.)

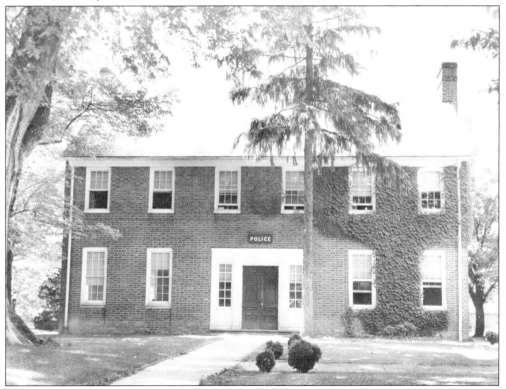

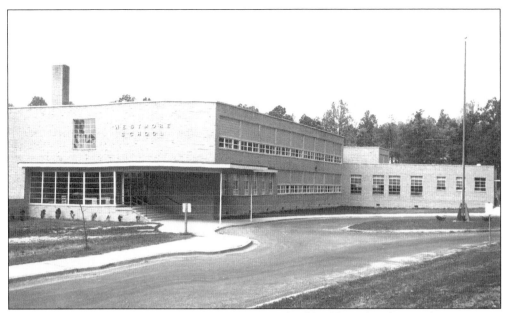

Formerly Westmore Elementary School, this 1950s school building closed to students in 2000. Since then, it has served as an administrative office for Fairfax County Public Schools and a home for Northern Virginia Christian Academy. This photograph of the school was taken in 1955. (Courtesy of the Virginia Room, Fairfax County Public Library.)

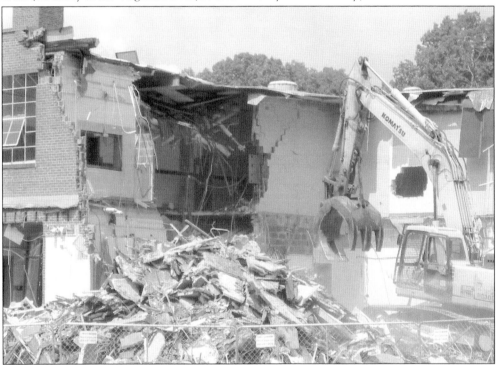

The former Westmore Elementary School building remained vacant for two years before the Fairfax City Council voted to demolish it for parkland in 2012. This photograph shows the demolition in progress later that year. (Courtesy of Ross Landis.)

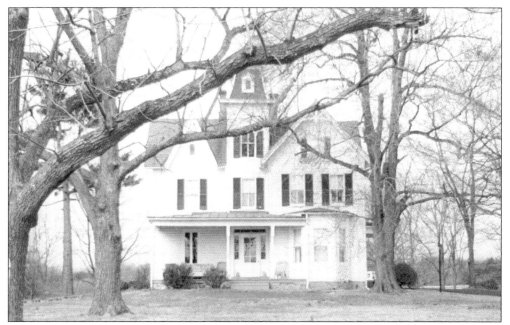

The Cobb House still stands off Chain Bridge Road at the entrance to Cobbdale. James H. Cobb and his wife, Ellen, lived in this house with their children, Norman, Albert, and Mavis. They moved to Fairfax from North Carolina before 1920. The Cobbdale community is named after the Cobb family. (Courtesy of the Virginia Room, Fairfax County Public Library.)

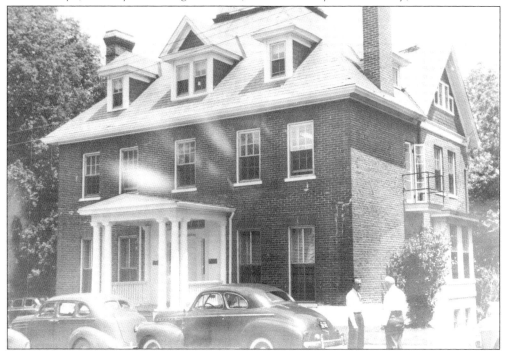

The Ford House was constructed in 1835. Now known as the Ford Building, the home stands on Chain Bridge Road, housing a special exhibit on the life of Antonia Ford and her family. The accusation that Ford was a spy during the Civil War was never proven. (Courtesy of Lee Hubbard.)

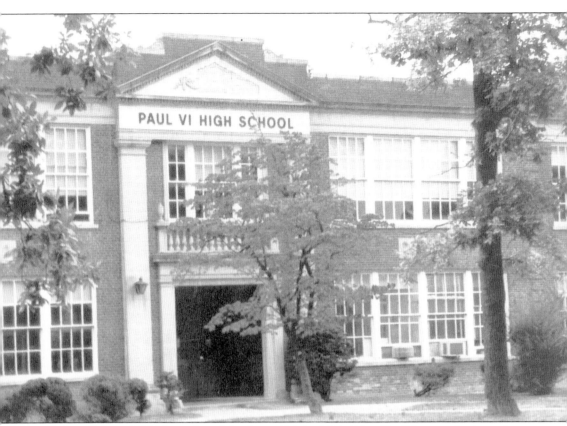

Bishop Thomas J. Welsh purchased the former Fairfax High School building on what's now known as Fairfax Boulevard from the George Mason Foundation for $2.2 million in 1982. The school opened its doors to Paul VI Catholic High School students in 1983. Fr. Donald Heet served as the founding principal. (Courtesy of Paul VI Catholic High School.)

Four

COMMUNITY

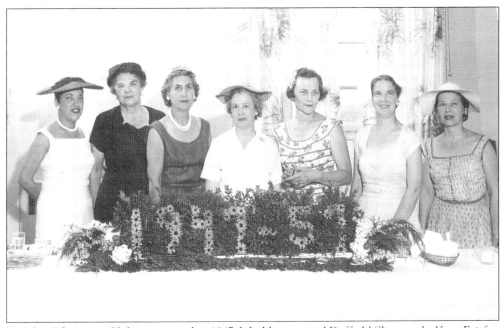

Tuesday Afternoon Club was created in 1947. It held an annual Daffodil Show and a Keep Fairfax Beautiful campaign. Club membership in 1957 included, from left to right, Mrs. Frank Butler ("Dickie"), Mrs. Thomas C. Henderson (Dorcas), Mrs. Walter M. Macomber (Marion), Mrs. Hampdin H. Smith, Jr. ("Kitty"), Mrs. Paul M. Cullan (Virginia), Mrs. C. Meade Stull ("Evie"), and Mrs. Paul Peter (Ruth "Snip"). (Courtesy of the Virginia Room, Fairfax County Public Library.)

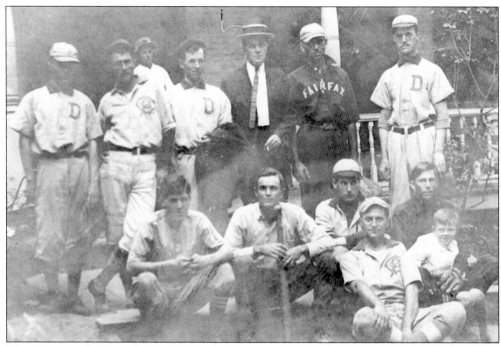

This photograph shows the Fairfax baseball team in 1911. The man seated on the right side of the group in the gray shirt is Elton Holbrook. In this photograph, he's holding his son, Frederick Wilmer Holbrook. (Courtesy of the Virginia Room, Fairfax County Public Library.)

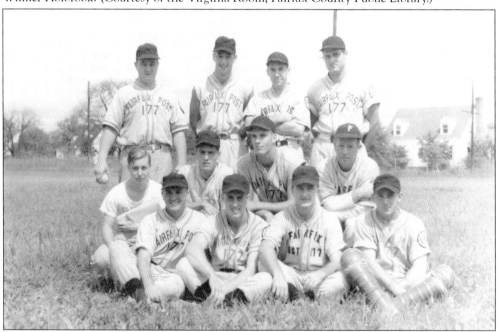

The American Legion baseball team won the Fairfax County championship in 1948. This photograph shows the 1948 team. Photographed above are Leslie Butler, Larry Fones, Frank Jones, Maurice Wooster, Billy Foltz, Alvin Hall, Bob Miller, Walter Sherwood, Walter Buckley, Bob Payne, Tab Wells, and Billy Hawes. (Courtesy of Lee Hubbard.)

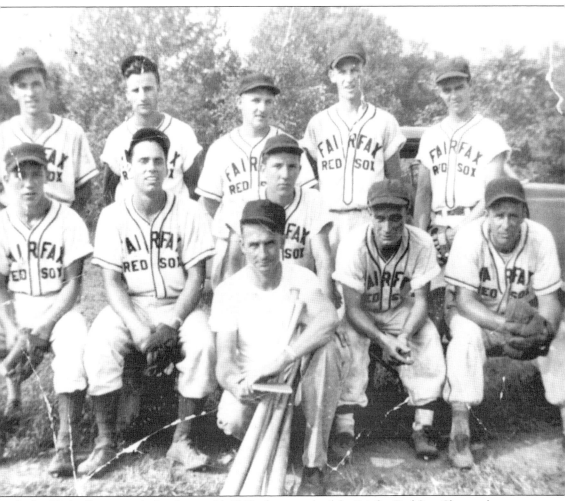

Jackie Taylor Pinson took this August 14, 1949, photograph of the Fairfax Red Sox. Shown above from left to right are (first row) Ernest Pinson; (second row) Buddy Borher, Joseph Feehan, Cecil Shelton, George Churchill, and Warren Jenkins; (third row) Wilbur Jenkins, Travis Hubbard, Raymond Downs, David Williams, and Gerald Feehan. Now the only baseball team in Fairfax with the Red Sox name belongs to the Fairfax Little League. That senior Little League team competes against the Cubs and the Mets. Fairfax Little League began in 1955 and has been active for over six decades. Chilcott Stadium was built in 1956. Thaiss Fields, located on Pickett Road across from the Fairfax Property Yard, were leased in 1959. The Little League split into three divisions, American, Dominion, and National, in 1968. The first girl played on a Fairfax Little League team in 1974. (Courtesy of Lee Hubbard.)

The Peters' Main Street home may have served as a Coombe Cottage dormitory. After the Civil War, circuit court justice James Love moved several of the dormitories to the south side of Main Street and leased them. This photograph shows the living room of the home in 1949 with, from left to right, Paul Peter, Dorothy D. Eckert, Paul B. Peter, and Ruth D. Peter. (Courtesy of the Virginia Room, Fairfax County Public Library.)

The Peter family lived on Main Street opposite Truro Church in the early 20th century. Located in the area of the current-day Casa Italia, the Peter home housed Paul and Ruth "Snip" Peter until they purchased a barn on Orchard Drive in the early 1950s and converted it into their new home. (Courtesy of the Virginia Room, Fairfax County Public Library.)

This photograph shows Ruth "Snip" Peter in the early 1950s. Peter operated the Greenwood School, a primary-grades-only school, from her new home on Orchard Drive in the early 1960s. Page Johnson, the current commissioner of revenue and local historian, and his wife, Susan, now live in the Orchard Drive Peter house. Susan used to attend the Greenwood School. During that time, the Peter house had about 20 acres with horses. The Peters subdivided their property in 1974, creating the Orchard Knolls subdivision. Peter was an active member in the Fairfax Garden Club and Tuesday Afternoon Club. Her husband, Paul, was a Fairfax High School government teacher. (Courtesy of the Virginia Room, Fairfax County Public Library.)

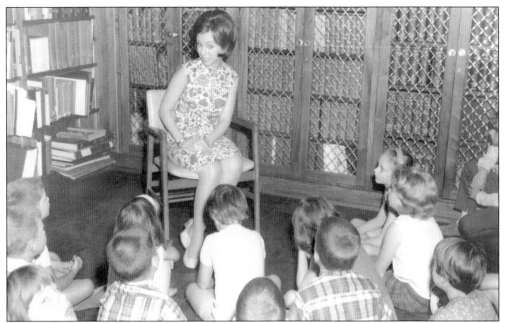

Children's librarian Carole Senda reads a book to a group of children in the Virginia Room at the City of Fairfax Regional Library in 1969. The library's youth outreach program continues today at the City of Fairfax Regional Library's location on North Street in downtown Fairfax. (Courtesy of the Virginia Room, Fairfax County Public Library.)

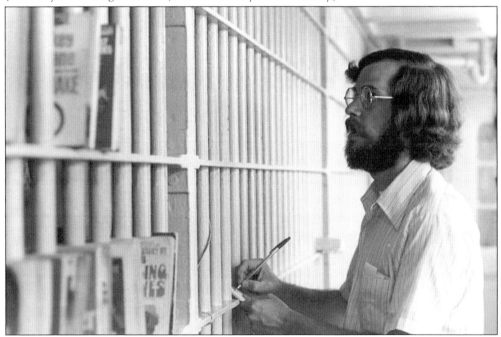

Librarian Joe Coleman visits the Adult Detention Center at the Fairfax County Judicial Center on Chain Bridge Road to distribute books to the inmates in this undated photograph. The jail still offers library services and reading programs today. (Courtesy of the Virginia Room, Fairfax County Public Library.)

This photograph shows Hannah Keith Howe standing in downtown Fairfax at the intersection of Chain Bridge Road and North Street in 1905. Shown in the background are a gaslight and the fence of the Moore-McCandlish House. John Mosby's Raiders searched the Moore House during the Civil War in search of Union colonel Percy Wyndham. Historians say the search was prompted by an insult. Supposedly, Wyndham called Mosby nothing but a horse thief, and the Confederate raider took offense. Mosby never found Wyndham at the Moore House. Thomas Moore purchased the Moore House when he moved to Fairfax. His son, R. Walton Moore, served in the US Congress from 1919 to 1931. He was the assistant secretary of state under Pres. Franklin D. Roosevelt in 1933. Mary LeGrand (Donohoe) McCandlish lived in the house with her uncle R. Walton Moore. Her father started the *Fairfax Herald*. (Courtesy of the Virginia Room, Fairfax County Public Library.)

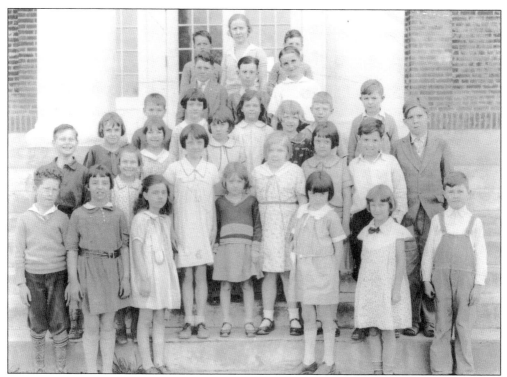

Fairfax Elementary School was built for $2,750 in 1873. The two-story building was used to also teach special and adult education. The school moved to a second location built in 1925. This photograph shows Mrs. Coyner's second grade class on the front steps of the 1925 Fairfax Elementary School in 1931. (Courtesy of the Virginia Room, Fairfax County Public Library.)

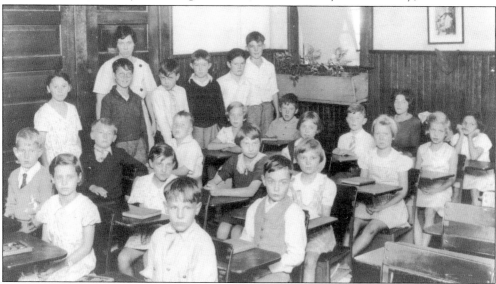

This photograph shows teacher Mary Thompson's third- and fourth-grade classes at Fairfax Elementary School in 1931. In 1992, the first elementary school building (constructed in 1873) became the Fairfax Museum and Visitor Center. (Courtesy of the Virginia Room, Fairfax County Public Library.)

Mosby Woods Elementary School students celebrate with a centennial event at the school on May 8, 1970. The school opened on September 3, 1963, in honor of Confederate Civil War raider John Singleton Mosby. (Courtesy of the Virginia Room, Fairfax County Public Library.)

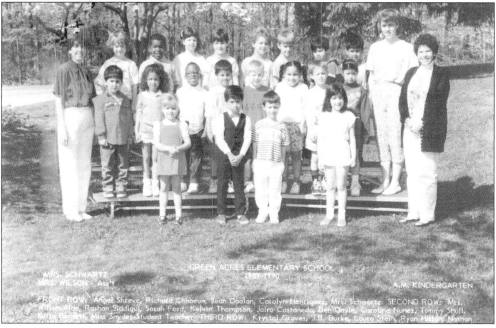

Mrs. Schwartz and Mrs. Wilson's kindergarten class at Green Acres Elementary School during the 1989–1990 school year is show here. In 2001, Green Acres and Layton Hall Elementary Schools closed. Their students moved to the new Daniels Run Elementary School. (Courtesy of the Fairfax Museum and Visitor Center.)

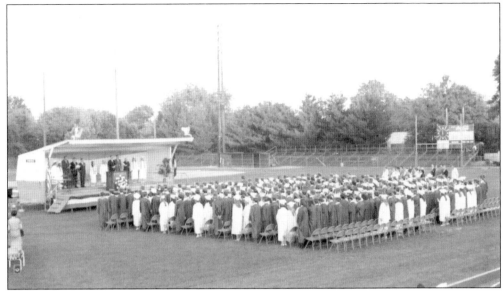

Construction of the new Fairfax High School started in May 1970, according to an archived *Virginia Sentinel* issue. It opened on January 3, 1972. The $8-million, 48-acre site in the eastern part of the city offered expanded athletic complexes, movable partitions, and carpeted classrooms among other modernities. This photograph shows the last graduation at the old school grounds on June 10, 1971. (Courtesy of the Virginia Room, Fairfax County Public Library.)

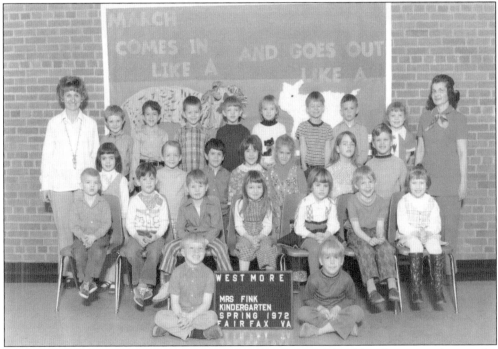

This photograph shows Mrs. Fink's Westmore Elementary School kindergarten class in the spring of 1972. Built in the 1950s, the Westmore Elementary School closed in 2000. Its students moved to Daniels Run Elementary School. (Courtesy of the Virginia Room, Fairfax County Public Library.)

This photograph shows Mrs. John Eisenhower and Ruth Peter giving Susan and horse Hue a ribbon in lead line call at the Fairfax High School riding club's horse show. The show took place on Capt. and Mrs. E.P. Aurand's grounds on May 9, 1959. Back then, students attended the original Fairfax High School building where Paul VI Catholic High School currently stands. The school was built on the old Fairfax County fairgrounds on Lee Highway in 1934. School officials received a $153,000 federal grant and borrowed $189,000 from the Literary Fund of Virginia to purchase the land, according to memos in the City of Fairfax Regional Library archives. Construction of the high school was completed on February 22, 1935. Students did not move to the new Fairfax High School building on Old Lee Highway until 1972. (Courtesy of the Virginia Room, Fairfax County Public Library.)

A group of musicians came together in 1957 to create the Fairfax Symphony. Still in existence today, the symphony boasts an annual operating budget of $1 million, holds a concert series at George Mason University, plays in Fairfax parks, and reaches about 52,000 audience members a year. This photograph shows Fairfax Symphony musicians performing a program preview at Oatlands in 1971. (Courtesy of the Virginia Room, Fairfax County Public Library.)

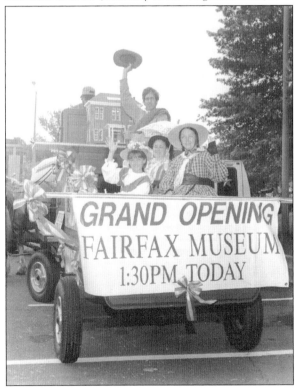

Fairfax Museum and Visitor Center opened in 1992. The museum operates out of the old Fairfax Elementary School, a two-story school building constructed in 1873. Historians and volunteers prepare and guide visitors through Fairfax's past with three exhibit rooms, a visitor center lobby, and storage for historical photographs, documents, and artifacts. This photograph shows the Fairfax Museum's opening day float in the city of Fairfax's July 4, 1992, parade. (Courtesy of the Fairfax Museum and Visitor Center.)

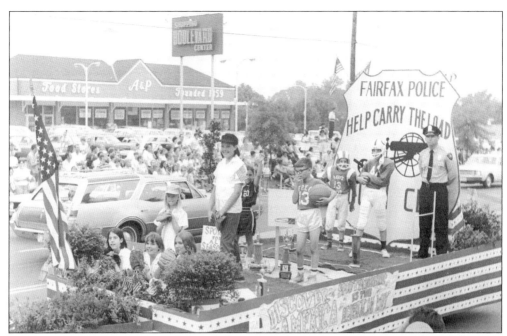

The Fairfax Police's "Help Carry the Load" float passes by the A&P grocery at Boulevard Shopping Center during the July 4, 1972, city of Fairfax parade in this photograph. The football players standing next to the officer are part of the department's Fairfax Police Youth Club. (Courtesy of the Fairfax Museum and Visitor Center.)

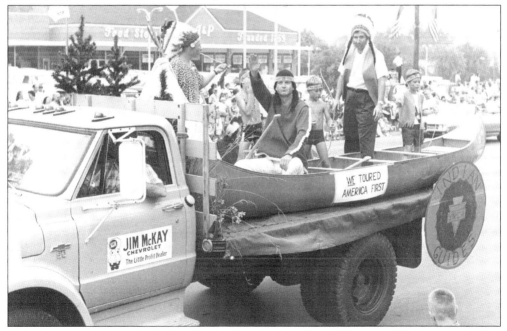

This photograph shows the Indian Guides float in the July 4, 1972, city of Fairfax parade. The Indian Guides (and sister group Indian Princesses) was a local YMCA organization. Members used to meet just east of Fairfax at the YMCA at Little River Turnpike and Prince William Drive. (Courtesy of the Fairfax Museum and Visitor Center.)

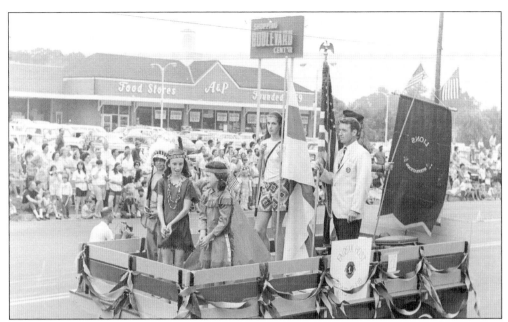

The Fairfax Host Lions Club, one of 70 clubs in Northern Virginia, helps local families and individuals in need by providing eye examinations and glasses, hearing exams and aids, service dogs, diabetes awareness programs, and a long list of other service projects. This photograph shows the club's float in the July 4, 1972, city of Fairfax parade. (Courtesy of the Fairfax Museum and Visitor Center.)

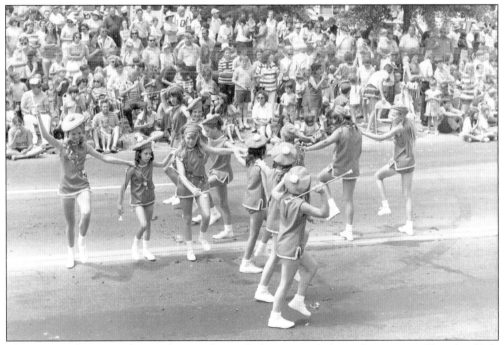

These young baton twirlers perform in front of a long, crowded parade route at a Fourth of July celebration in the city of Fairfax. This photograph was taken on July 4, 1972. (Courtesy of the Fairfax Museum and Visitor Center.)

This photograph shows B.S. Gillespie's son, Berkeley S. Gillespie Jr., standing in Fairfax in the 1920s, when he was seven years old. He is shown in front of his father's Texaco service station. (Courtesy of the Virginia Room, Fairfax County Public Library.)

B.S. Gillespie lived with his family on Cedar Avenue in Fairfax in the 1920s. He built and operated a Texaco station near the corner of what is now known as Old Lee Highway and Main Street. He added on to the Texaco station in 1931, thanks to booming business. (Courtesy of the Virginia Room, Fairfax County Public Library.)

This photograph shows the Gillespie kids and their friends at a Fairfax swimming pool in the 1920s. B.S. Gillespie and his wife had at least one daughter and one son, according to the *Fairfax Herald*. (Courtesy of the Virginia Room, Fairfax County Public Library.)

The caption on this photograph indicates that these people are B.A., Mrs. Jones, and Chaddy on Cedar Avenue, where the Gillespies lived. The photograph was taken in Fairfax in the 1920s. (Courtesy of the Virginia Room, Fairfax County Public Library.)

This photograph's cryptic caption only states the initials of those present, S.M., H.R., J.R., T.R., E.R., and E.M. The photograph shows a group of five teenagers standing in front of a car in Fairfax in the 1920s. It is part of the Gillespie album. (Courtesy of the Virginia Room, Fairfax County Public Library.)

Berkeley Gillespie and his sister Vivian were often on the Fairfax High School honor roll, according to *Fairfax Herald* records. Both won multiple awards at the town's flower show. Like any rambunctious kid, Berkeley fractured his arm in a fall, and as an active Boy Scout, he got to visit a naval observatory with his troop. Vivian joined a bridge club. (Courtesy of the Virginia Room, Fairfax County Public Library.)

This photograph shows, from left to right, Berkeley Gillespie Jr., Jimmy Nickell, and Frank Young sitting in front of a tree in Fairfax in the 1920s. Gillespie Sr. was elected as a Republican alternative delegate in March 1928. He also represented the Henry Lodge, joined the Fairfax Chamber of Commerce, and served as the Fairfax Volunteer Fire Department chief. B.S. Gillespie retired from the fire department in June 1929. (Courtesy of the Virginia Room, Fairfax County Public Library.)

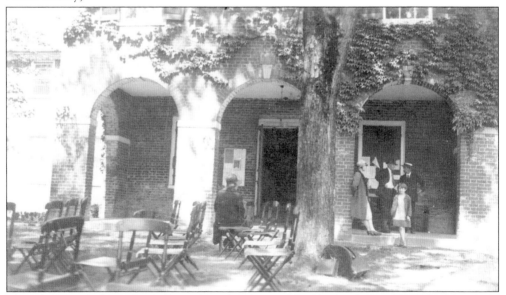

This photograph shows the Gillespie brood in front of the Fairfax County Courthouse in 1931 for Old Soldier's Day. Mrs. Gillespie served as a women's auxiliary officer and a Girl Scout troop leader in the late 1920s. (Courtesy of the Virginia Room, Fairfax County Public Library.)

This photograph shows a crowd at an artist signing event at the Fairfax County Courthouse in 1996. The event, sponsored by the Virginia Room, featured Mort Kunsler signing prints of his work *The Fairfax Raid*. Carol Sinwell is shown in the center. (Courtesy of the Virginia Room, Fairfax County Public Library.)

This photograph shows librarian Dorothy Mason talking to residents of the Fairfax Nursing Home as part of an outreach program in 1973. The library system still visits nursing homes as part of its Changing Lives Through Literature program. (Courtesy of the Virginia Room, Fairfax County Public Library.)

These photographs show Fairfax County Public Library's booths at the city of Fairfax's annual Fall Festival event in 1979. What started as a small event for local artisans to display their creations is now in its 36th year. The event has grown to take over most of the downtown district, with over 400 crafts sellers, food vendors, and live entertainment. Now, a free shuttle service buses in residents and their families. The Fall Festival is one of several large festival events held in Fairfax. Locals routinely pack Old Town Hall for the city's annual Chocolate Lover's Festival and crowd into the Kitty Pozer Garden for the tree lighting ceremony and activities. Every year, citizens from all over travel to Fairfax for George Mason University's weeklong Fall for the Book event. (Both, courtesy of the Virginia Room, Fairfax County Public Library.)

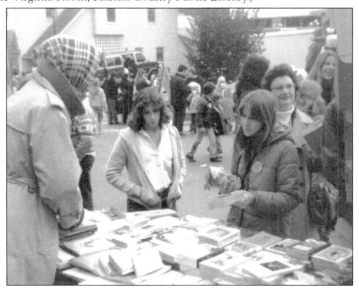

The City of Fairfax Regional Library Cart Precision Drill Team performs at the 1984 city of Fairfax Fourth of July parade in this photograph. The cart drill team started a year earlier, performing for the first time in the parade on July 4, 1983. The first in the region, the team began as a creative way for library staff to publicize renovations and temporary housing for the library branch. (Courtesy of the Virginia Room, Fairfax County Public Library.)

The Westmore Teen Queen gets the royal treatment with a tiara, flowers, and car escort in her trip down the packed July 4, 1971, parade route in the city of Fairfax. The city holds a similar parade every year on Independence Day. (Courtesy of the Virginia Room, Fairfax County Public Library.)

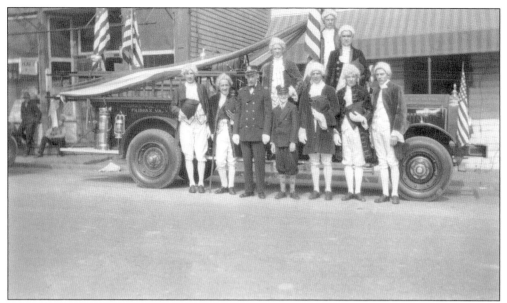

From left to right, (first row) Lewis Coyner, Franklin Sagendorf, Chaley L. Smith, C. Ritchie, fire chief Allen Williams, unidentified, and George Tate; (second row) J.E. Nickell, Elmer Dove, and John Sisson pose on a truck decorated for the City of Fairfax in February 1932. (Courtesy of the Virginia Room, Fairfax County Public Library.)

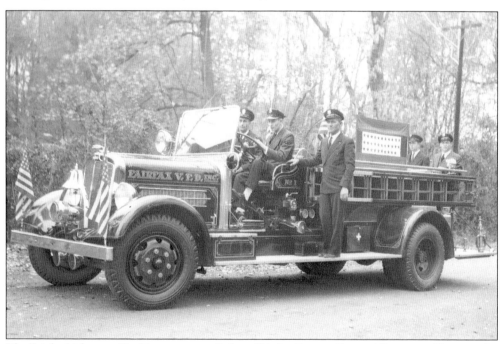

The Fairfax Volunteer Fire Department split from Fairfax County Fire and Rescue and became the City of Fairfax Fire Department in May 1978. It built two fire stations: one on Lee Highway and a second, owned by the department's volunteer division, on University Drive. Eleven personnel staffed both stations, with volunteers helping on nights and weekends. Joseph Gebauer was the first fire chief, leading the department from 1977 to 1980. (Courtesy of Lee Hubbard.)

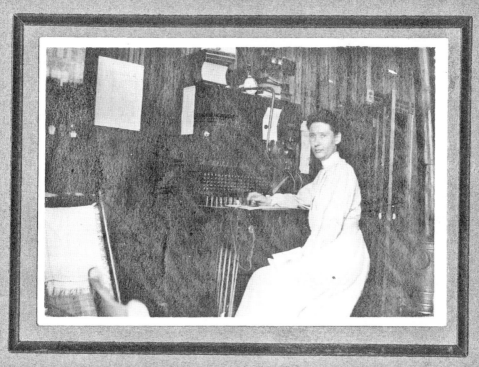

maggie swayze, telephone operator

Maggie Swayze and her sisters, Ora and Minnie, lived next to the Methodist parsonage. Swayze was one of the first telephone operators in Fairfax, if not the first. The first switchboard for Fairfax was located in an old building across Main Street from the original *Fairfax Herald* site. The telephone company was moved in 1955 to a building on University Drive built by the Grefe brothers. Many of the town's telephone operators left Fairfax when the phone company switched to a dial system. Maggie Swayze is shown at her switchboard. (Courtesy of Lee Hubbard.)

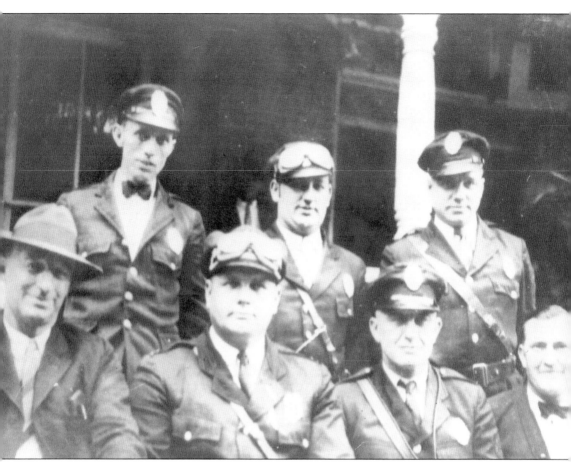

Taken around June 1928, this old police photograph shows officers from before the start of the Fairfax County Police Department. Shown from left to right are (first row) Sheriff Eppa Kirby, Officer Haywood Durrer, Officer John Millan, and jailor Mr. Darr; (back row) Deputy Sheriff Henry T. Magarity, Deputy Richard Wheeler, and Officer Carl McIntosh. McIntosh became the county's first chief of police when the Fairfax County Police Department was formed in 1940. The Fairfax Town Council selected its first uniformed officer, Haywood Mayberry, in 1948. The city's police officers were Ed Bloomfield, Calvin Long, and Howard Stull. The Fairfax City Council appointed C.F. Young as the first chief of police in 1954. Fairfax officers attended academy training with Fairfax County police. The town police department did not change its name to the City of Fairfax Police Department until 1961. (Courtesy of Lee Hubbard.)

The Fairfax Hardware Coffee Group met in the mornings at Fairfax Hardware, then at the nearby McDonald's after Fairfax Hardware closed. This photograph shows, from left to right, Walter Morris, Vince Sutphin, former City of Fairfax council member Pat Rodio, and Billy Fregans in June 1992. (Courtesy of the Fairfax Museum and Visitor Center.)

This photograph shows, from left to right, Bob Vanhouten, Walter Morris, and Vince Sutphin during a Fairfax Hardware Coffee Group meeting in June 1992. The photograph was taken at Fairfax Hardware in the city of Fairfax. (Courtesy of the Virginia Room, Fairfax County Public Library.)

Oliver B. Campbell ran a plumbing and contracting business in his house at Lee Highway and Main Street. He also owned many of the buildings on that end of the block. He gave the land and constructed the building for the congregation of the newly formed Fairfax Baptist Church in 1924, now Fred Codding's office building. Campbell and his wife provided a home for young boys and girls. (Courtesy of Lee Hubbard.)

These children stand at the Fairfax Cemetery during Confederate Memorial Day. The man standing to the left of the monument without a hat is thought to be Joseph E. Willard, the man who bought Dunleith and built Layton Hall. The child holding the flag in the center of the photograph is Frederick Wilmer Holbrook. (Courtesy of the Fairfax Museum and Visitor Center.)

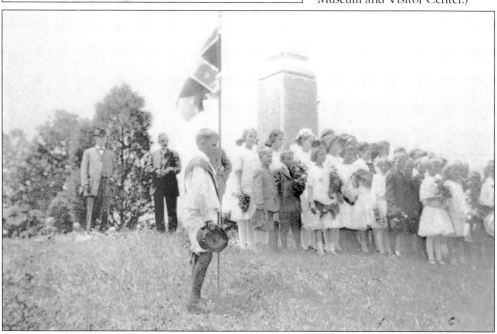

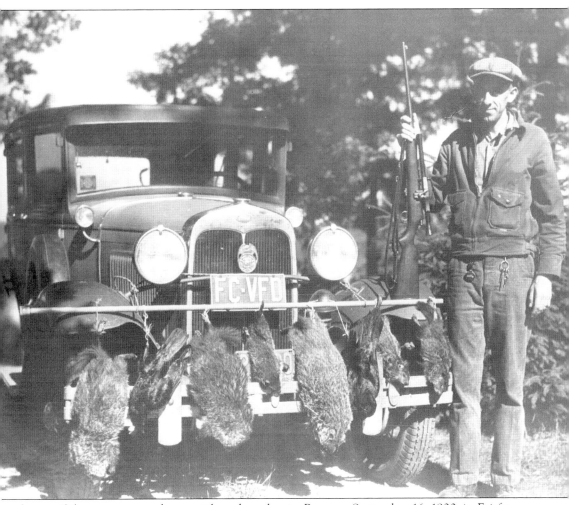

Jerome Gibson was an avid gunsmith and mechanic. Born on September 16, 1900, in Fairfax Station, he repaired guns and built custom rifles for hunting and target shooting until he was about 93 years old. This photograph shows him after a groundhog hunt in the Fairfax area around 1931. Farmers still hunt for groundhogs today, mostly to clear fields of the pests. Groundhogs eat crops and dig holes into the ground, a danger to horses and grazing cows. Jerome Gibson married Marie Swayze in 1927. That same year, he built a Sears Roebuck house just south of his auto repair garage on Lee Highway and Blake Lane. Much of his gun work took place in that house, where he ran his munitions repair business. Jerome and Marie lived their entire married life in that house. (Courtesy of Lee Hubbard.)

This photograph shows Bethel Moore and baby Karen Ann Moore crossing the road at Chestnut and Milburn Streets. The photographer, Glenn Moore, was standing on the porch at 4100 Chestnut Street looking northeast in 1954. The two houses shown are 4037 and 4039 Chestnut Street. Photographs like this depict a different city of Fairfax than the Fairfax Court House area of the 19th century. The time of large plantations ended after the Civil War. Virginia rejoined the Union in 1870, after Reconstruction. The rural, small-farm society still existed, but it slowly disappeared as the area became more populated. Now, Fairfax is largely residential, with two-level homes and fenced yards. Business boulevards run the width of the city's boundaries, with a historic downtown preserved in the middle. (Courtesy of the Virginia Room, Fairfax County Public Library.)

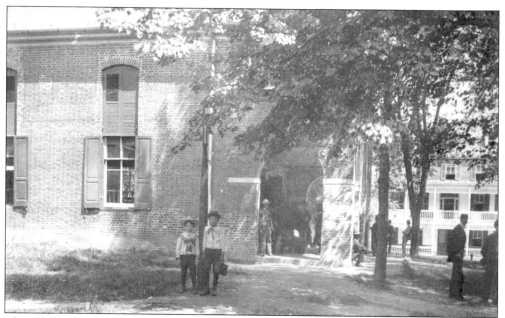

These kids pose for a photograph in front of the Fairfax County Courthouse in this undated photograph taken prior to 1932. On August 4, 1853, the courthouse was almost destroyed in a fire. William H. Dulany's and William L. Edwards's law offices, Dr. William Gunnell's medical office, the offices of *Fairfax News*, and Mrs. Hunt's home were overcome by the flames. The cause of the fire was never identified. (Courtesy of Lee Hubbard.)

This photograph shows the Virginia Bicentennial celebration in the Massey Building plaza at the Fairfax County Judicial Center in the city of Fairfax on Chain Bridge Road. It was taken on July 29, 1976. (Courtesy of the Virginia Room, Fairfax County Public Library.)

Former city of Fairfax mayor George Hamill speaks at the podium in front of the Fairfax Museum and Visitor Center on the center's grand opening in 1992. The Fairfax Museum is located in the old Fairfax Elementary School building on Main Street. (Courtesy of the Fairfax Museum and Visitor Center.)

This photograph shows the crowd at the grand opening of the Fairfax Museum and Visitor Center in 1992. John Gano, president of Historic Fairfax, Inc., from 1898 to 1995, and James Moyer, member of the Mosby Historical Society, also spoke at the celebration. (Courtesy of the Fairfax Museum and Visitor Center.)

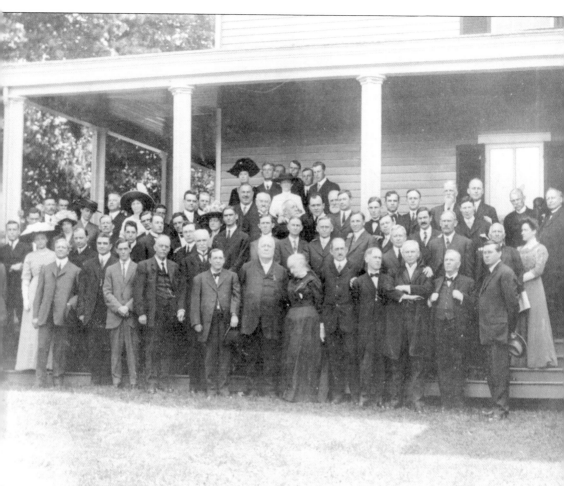

A large group of people stands in front of the Conrad House, now known as the Moore House, in this undated photograph. R. Walton Moore; his mother, Hannah Morris Moore; F.W. Richardson; C. Vernon Ford; and William E. Graham are shown standing in the crowd. R. Walton Moore served as a member of the US House of Representatives for Virginia. He was tasked with working on a route from Washington, DC, to Mount Vernon in 1928. The *Fairfax Herald* reported that the route was "intended to be one of the outstanding memorials in commemoration of the bicentennial of Washington's birth." It was scheduled to be completed in 1932. Moore took his niece, Mary McCandlish, on a plane ride over Washington, DC. According to the *Herald*, the pilot of the plane was Col. Charles Lindbergh. (Courtesy of Lee Hubbard.)

INDEX

Discover Thousands of Local History Books
Featuring Millions of Vintage Images

Arcadia Publishing, the leading local history publisher in the United States, is committed to making history accessible and meaningful through publishing books that celebrate and preserve the heritage of America's people and places.

Find more books like this at
www.arcadiapublishing.com

Search for your hometown history, your old stomping grounds, and even your favorite sports team.